# PROMOTION

ROCKPORT
PUBLISHERS

ROCKPORT PUBLISHERS, INC.
ROCKPORT, MASSACHUSETTS

First published in the United States of America by:
Rockport Publishers, Inc.
146 Granite Street
Rockport, Massachusetts 01966
Telephone: (508) 546-9590
Fax: (508) 546-7141

Other Distribution by:
Rockport Publishers, Inc.
Rockport, Massachusetts 01966

Cover Contributors:
(Clockwise from top left)
The Bradford Lawton Design Group
Paul Davis Studio
Siebert Design Associates
Mires Design, Inc.
Segura
Charles S. Anderson Design Co.

ISBN 1-56496-157-5

10 9 8 7 6 5 4

Printed in Hong Kong

# INTRODUCTION

All graphic design is, in its own way, a form of promotion: Posters, corporate identity programs, direct mail campaigns, product packaging, product design, exhibit design, brochure design, letterheads and business cards, restaurant menus and matchbooks.

This volume of the *Design Library* series presents the best of recent promotional design and provides not only an overview of the most creative promotional material of the decade, but also a collection which defines the "umbrella" industry of graphic design.

Every design created today must be given special consideration: Every T-shirt and ticket stub makes a statement and is an important factor in how a product, service, event, or company will be perceived by the consumer. Everything related to a product or service functions as a promotional piece.

As a designer, knowing what your client wants to communicate is just a small part of creating a successful promotional campaign. A great promotion will not only generate the desire or need for a product, but will create a thirst for the actual promotional piece. Grateful Dead ticket stubs, Absolut Vodka posters, Black Dog Bakery T-shirts, Hard Rock Cafe paraphernalia, and Disney toys and clothes have all become just as desirable as the products and places they were designed to promote. A great promotional piece not only gets a second look or makes a sale—it has a life of its own.

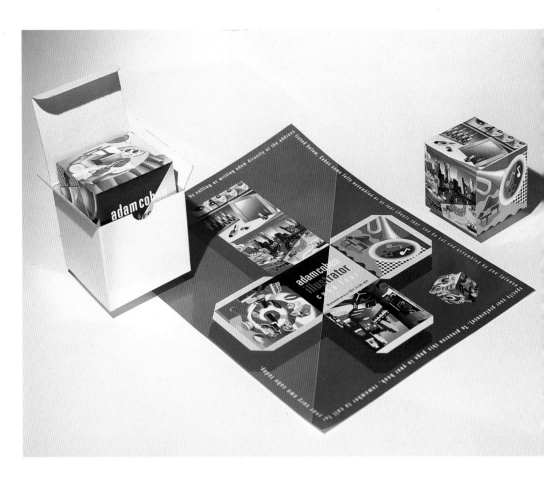

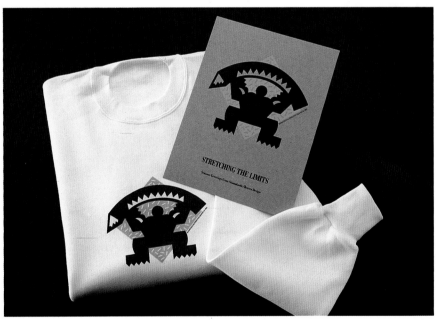

FROM TOP RIGHT

According to illustrator Adam Cohen, the unusual format of this illustrated cube, mailed in a simple white box, never fails to catch the attention of prospective clients. "I've received letters and phone calls from people who have seen it and want one," says Cohen.

**DESIGN FIRM** ADAM COHEN ILLUSTRATOR
**ART DIRECTOR/DESIGNER/ILLUSTRATOR** ADAM COHEN
**CLIENT** ADAM COHEN ILLUSTRATOR

This card and gift of a custom-designed sweatshirt went out to clients and vendors over the holidays. As wearable art, the sweatshirt helped to increase visibility for Shimokochi Reeves. "We do this as our holiday promotion every year," says firm principal Anne Reeves. "People love them."

**DESIGN FIRM** SHIMOKOCHI/REEVES
**ART DIRECTOR/DESIGNER** MAMORU SHIMOKOCHI, ANNE REEVES
**CLIENT** SHIMOKOCHI/REEVES

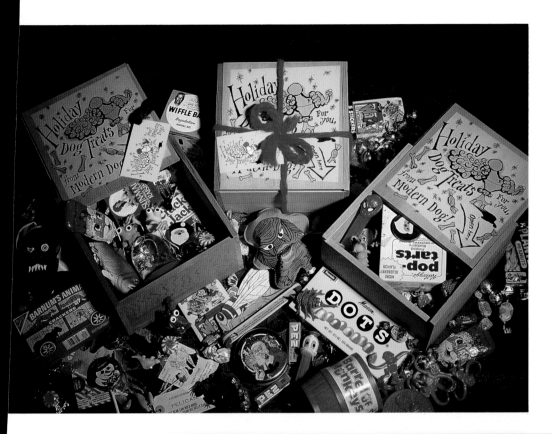

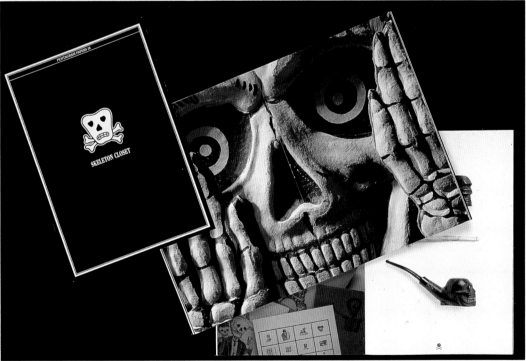

It's hard to ignore or forget this exhuberant assortment of goodies, hand-assembled in a custom package and sent to potential and existing clients as a holiday greeting.

**DESIGN FIRM** MODERN DOG
**ART DIRECTOR/DESIGNER** ROBYNNE RAYE,
   MICHAEL STRASSBURGER
**ILLUSTRATOR** MICHAEL STRASSBURGER

"Pentagram Papers" is a series of promotional brochures that the design firm sends on a regular basis to prospective and existing clients. This particular mailer, focusing on skeletons, was sent around Halloween.

**DESIGN FIRM** PENTAGRAM
**ART DIRECTORS** JOHN MCCONNELL, WOODY PIRTLC
**DESIGNER** WOODY PIRTLE
**PHOTOGRAPHER** BILL WHITEHURST
**ILLUSTRATOR** STEVEN GUARNACIA
**CLIENT** PENTAGRAM

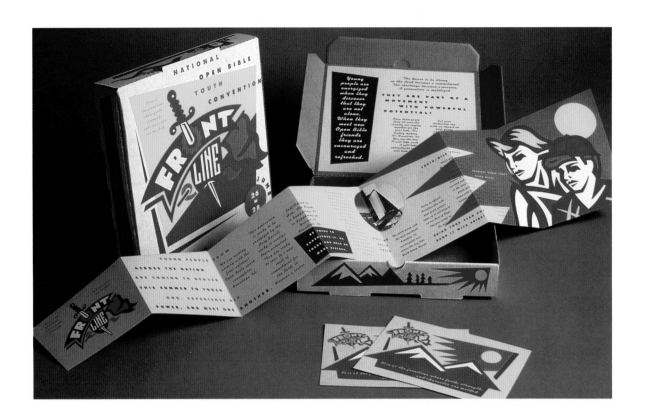

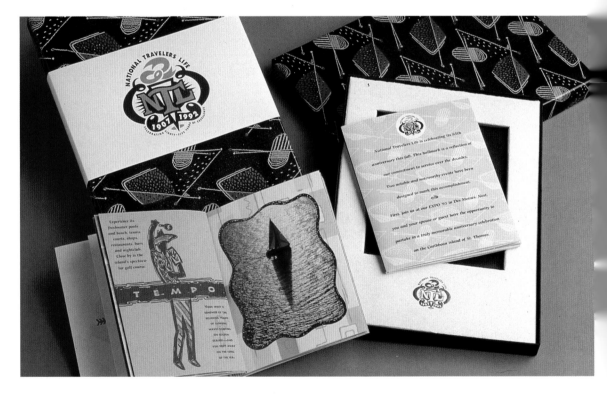

This multicomponent mailer, promoting a national youth convention, arrived in a colorful box that opens to reveal a die-cut brochure and collection of postcards.

**Design Firm** Sayles Graphic Design
**Art Director/Designer** John Sayles
**Illustrator** John Sayles
**Client** Open Bible Churches

Designed to promote a sales incentive trip, this screw-post bound brochure was mailed in a custom-designed box.

**Design Firm** Sayles Graphic Design
**Art Director/Designer** John Sayles
**Illustrator** John Sayles
**Client** National Travelers Life

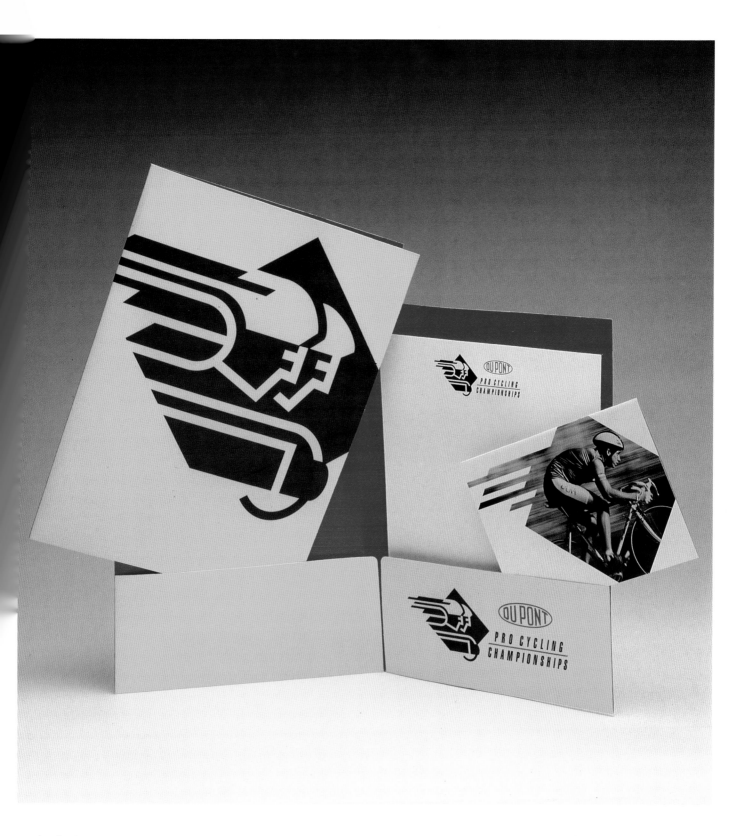

A series of swim meets sponsored by Dupont requires a coordinated package of various promotional materials that are mailed to national as well as local media.

**DESIGN FIRM** MIKE QUON DESIGN OFFFICE
**ART DIRECTOR** MIKE QUON, L. STEVENS
**ILLUSTRATOR** MIKE QUON
**CLIENT** DUPONT

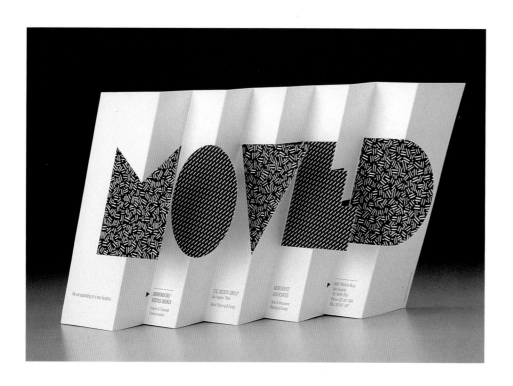

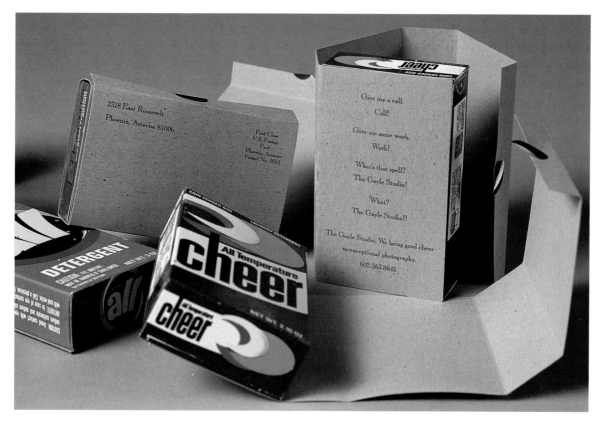

FROM TOP LEFT

A move to a new studio presents an opportunity for a promotional mailing. This piece's accordian folds and unique graphics encourage additional exposure as a stand-up display. "We've won numerous awards with it," says firm principal Anne Reeves, citing additional promotional mileage this recognition brought.

**DESIGN FIRM** SHIMOKOCHI/REEVES
**ART DIRECTOR/DESIGNER** MAMORU SHIMOKOCHI, ANNE REEVES
**CLIENT** SHIMOKOCHI/REEVES

A message of holiday "Cheer" is literally depicted in this memorable promotion for a well-known photographer. "We wanted to promote him in a different way," says firm principal Forrest Richardson, who says this mailing stood out from the more mundane "portfolio" pieces photographers typically send out.

**DESIGN FIRM** RICHARDSON OR RICHARDSON
**ART DIRECTOR/DESIGNER** DEBI YOUNG MEES
**COPYWRITERS** VALERIE RICHARDSON, DEBI YOUNG MEES
**CLIENT** RICK GAYLE STUDIO INC.

8

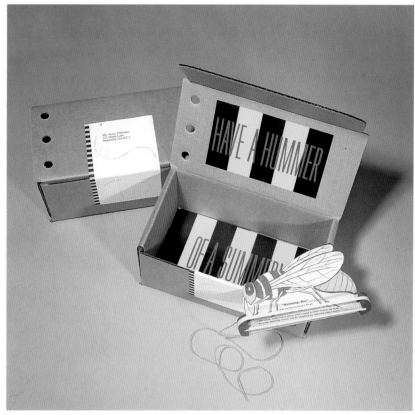

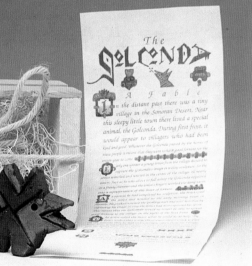

TOP RIGHT

WYD traditionally sends an annual self-promotion with a summer theme to existing and prospective clients. This self-promotion includes a bee that actually hums when it's whirled overhead. Firm principal Frank Oswald says the piece generated goodwill and prompted many thank-you calls from clients. A year later, "We're still getting requests for bees," he says.

**Design Firm** WYD Design, Inc.
**Art Director** Randall Smith
**Designer/Copywriter** Scott Kuykendall
**Client** WYD Design, Inc.

ABOVE AND TOP LEFT

The Golconda, a mythological creature Boelts Bros. created, serves as the basis for this promotional holiday mailing which includes a recounting of the Golconda legend and a ceramic miniature as a keepsake. "A fable was written," says principal Jackson Boelts, "and it was sent out in its own little wooden pen."

**Design Firm** Boelts Bros. Design, Inc.
**Art Director/Designer** Eric Boelts, Jackson Boelts, Kerry Stratford
**Client** Boelts Bros. Design, Inc.

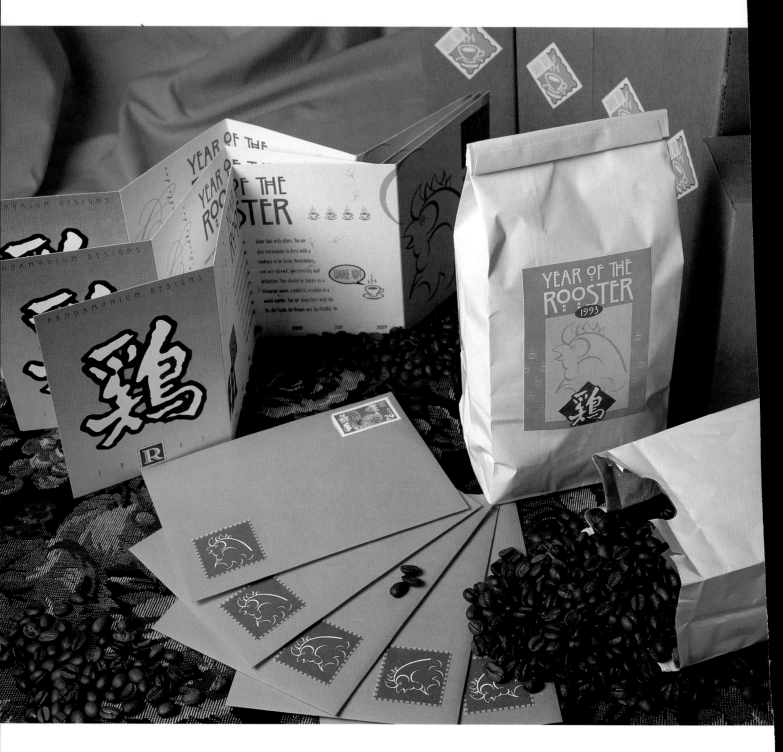

This well-coordinated promotional mailing, consisting of custom-packaged coffee, a greeting card, and special shipping boxes and labels, celebrates the Chinese Zodiac's Year of the Rooster. "We picked up a few clients and additional business from current ones as a result of this mailing," says firm principal Raymond Yu.

**DESIGN FIRM**  PANDAMONIUM DESIGNS
**ART DIRECTOR**  RAYMOND YU
**DESIGNERS**  RAYMOND YU, ERIN KRONINGER
**PHOTOGRAPHER**  STEVEN H. LEE
**CLIENT**  PANDAMONIUM DESIGNS

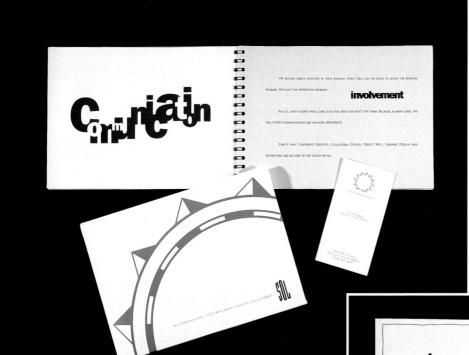

This self-promotion artfully packages a variety of logo jobs. The distinctive outer mailer echoes the simplicity of its contents yet is eye-catching enough to catch a recipient's attention. "This promotional package put us on the map and helped me establish my business," says firm principal Carlos Segura.

**DESIGN FIRM** SEGURA INC.
**ART DIRECTOR/DESIGNER** CARLOS SEGURA
**ILLUSTRATOR** CARLOS SEGURA
**CLIENT** SEGURA INC.

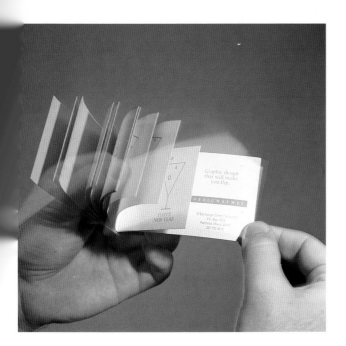

Sent to clients and prospects as a holiday greeting, this animated, hand-assembled flip book shows the metamorphasis of a simple line sketch of a Christmas tree (at the opening) into a New Year's champagne glass (at the end). "People kept it," says designer Dan Howard. "It keeps our name in front of our clients."

**DESIGN FIRM** DESIGNSENSE
**DESIGNER** DAN HOWARD
**CLIENT** DESIGNSENSE

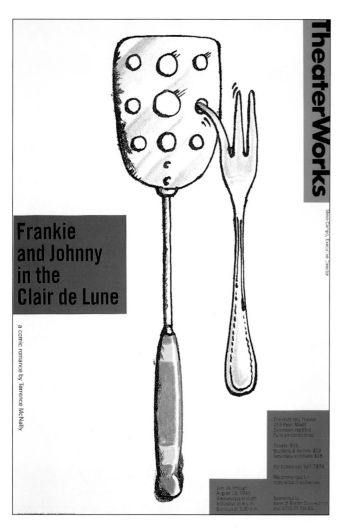

**TheaterWorks**

Steve Campo, Executive Director

**Frankie
and Johnny
in the
Clair de Lune**

a comic romance by Terrence McNally

The Hutensky Theater
233 Pearl Street
Downtown Hartford
Fully air-conditioned

Tickets: $18
Students & seniors: $13
Saturdays all tickets $18

For tickets call 527-7838

Recommended for
mature adult audiences.

July 16 through
August 15, 1993
Wednesdays through
Saturdays at 8 p.m.
Sundays at 2:30 p.m.

Sponsored by
Bank of Eastern Connecticut
and WTIC-TV Fox 61.

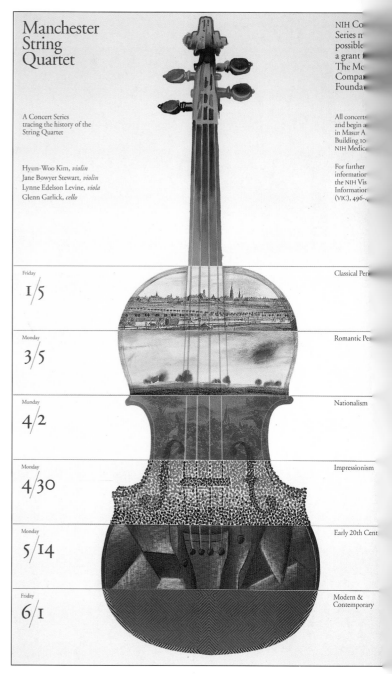

**Manchester
String
Quartet**

NIH Co
Series m
possible
a grant f
The Me
Compa
Founda

A Concert Series
tracing the history of the
String Quartet

All concerts
and begin a
in Masur A
Building 10
NIH Medica

Hyun-Woo Kim, *violin*
Jane Bowyer Stewart, *violin*
Lynne Edelson Levine, *viola*
Glenn Garlick, *cello*

For further
information
the NIH Vis
Information
(VIC), 496-4

| Friday 1/5 | Classical Peri |
| Monday 3/5 | Romantic Per |
| Monday 4/2 | Nationalism |
| Monday 4/30 | Impressionism |
| Monday 5/14 | Early 20th Cent |
| Friday 6/1 | Modern & Contemporary |

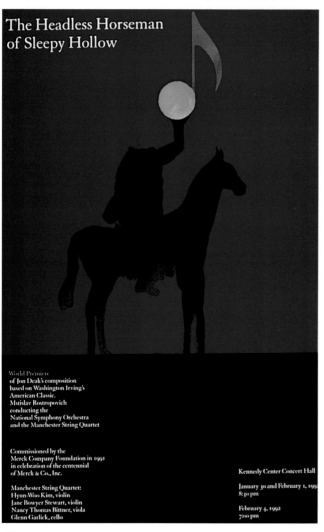

**The Headless Horseman
of Sleepy Hollow**

World Premiere
of Jon Deak's composition
based on Washington Irving's
American Classic.
Mstislav Rostropovich
conducting the
National Symphony Orchestra
and the Manchester String Quartet

Commissioned by the
Merck Company Foundation in 1991
in celebration of the centennial
of Merck & Co., Inc.

Manchester String Quartet:
Hyun-Woo Kim, violin
Jane Bowyer Stewart, violin
Nancy Thomas Bittner, viola
Glenn Garlick, cello

Kennedy Center Concert Hall

January 30 and February 1, 1992
8:30 pm

February 4, 1992
7:00 pm

CLOCKWISE FROM TOP LEFT

**Event** Frankie and Johnny in the Clair de Lune
**Description of Piece(s)** Poster
**Design Firm** Peter Good Graphic Design
**Art Director** Peter Good
**Designer** Peter Good
**Illustrator** Peter Good

**Event** Manchester String Quartet
**Description of Piece(s)** Poster
**Design Firm** Peter Good Graphic Design
**Art Director** Peter Good
**Designer** Peter Good
**Illustrator** Peter Good

**Event** Headless Horseman
**Description of Piece(s)** Poster
**Design Firm** Peter Good Graphic Design
**Art Director** Peter Good
**Designer** Peter Good
**Illustrator** Peter Good

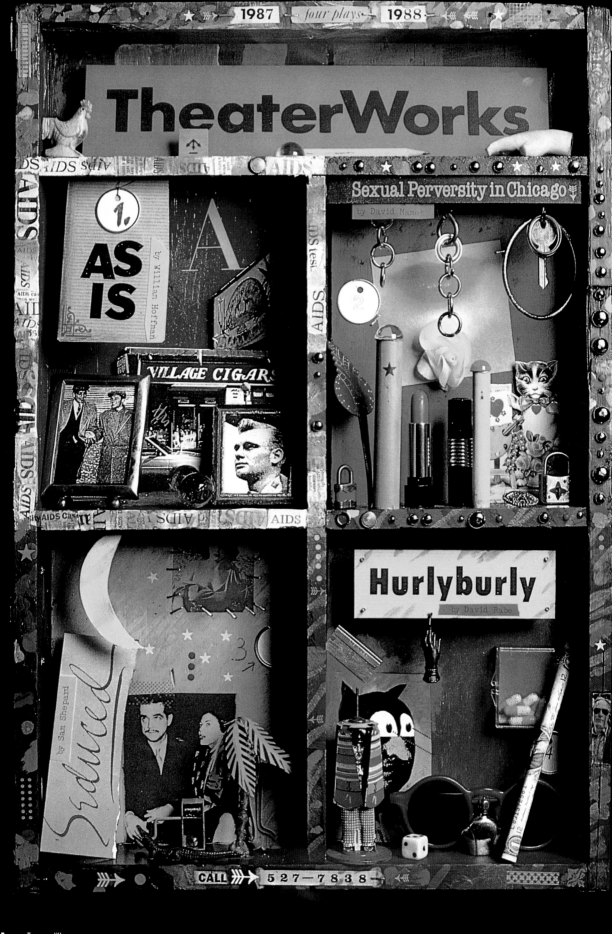

EVENT TheaterWorks
DESIGNER Peter Good
ILLUSTRATOR Peter Good
PHOTOGRAPHER Jim Coon

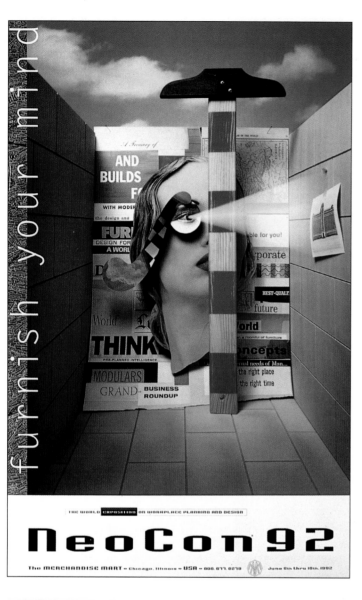

**Event** Neocon
**Description of Piece(s)** Brochure, stationery, postcards, direct mail, poster
**Design Firm** Segura Inc.
**Art Director** Carlos Segura
**Designer** Carlos Segura
**Photographer** Geof Kern

# nEOCON/92

## THE WORLD EXPOSITION ON WORKPLACE PLANNING AND DE

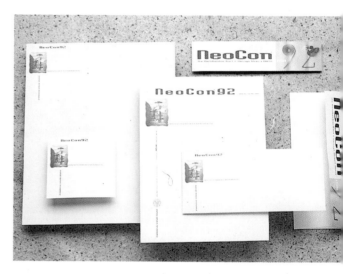

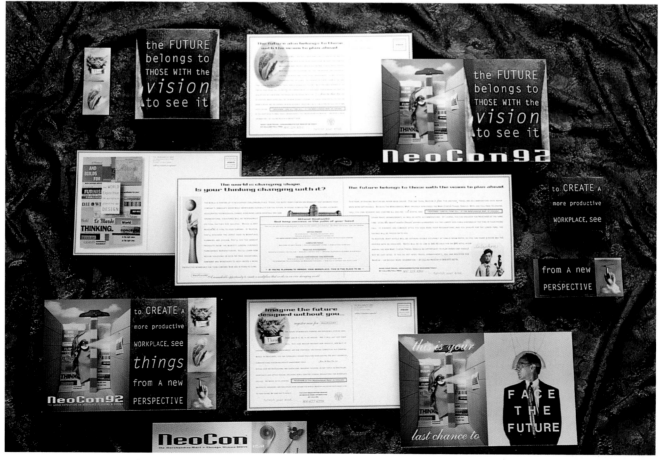

14

**Event** Melbourne International Arts Festival
**Description of Piece(s)** Banner, poster,
leaflet, T-shirt, program
**Design Firm** Cato Design Inc.
**Designer** Ken Cato

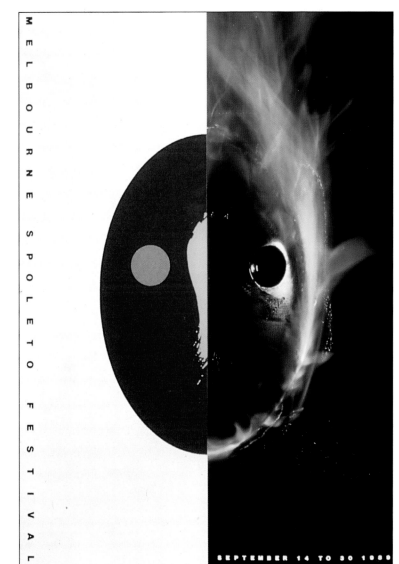

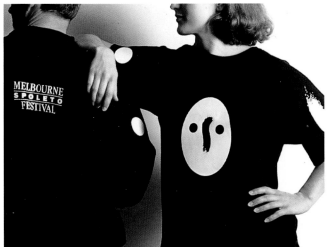

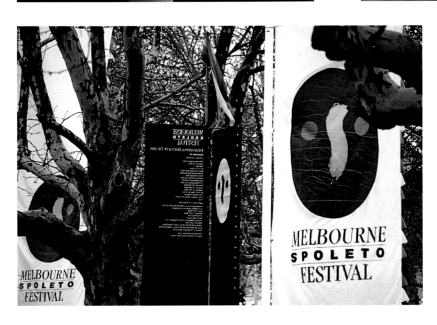

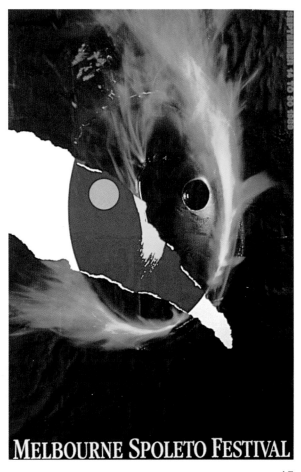

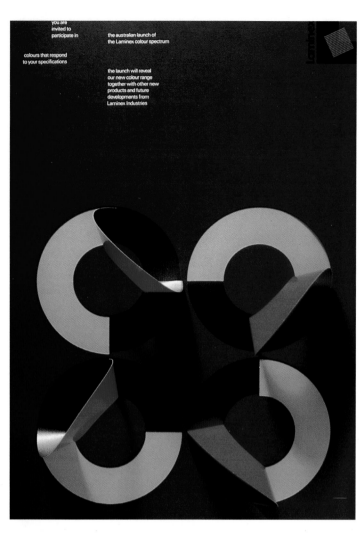

you are
invited to
participate in

the australian launch of
the Laminex colour spectrum

colours that respond
to your specifications

the launch will reveal
our new colour range
together with other new
products and future
developments from
Laminex Industries

**EVENT** LAMINEX INDUSTRIES EXHIBITION
**DESCRIPTION OF PIECE(S)** 3-D SCULPTURES
**DESIGN FIRM** CATO DESIGN INC.
**DESIGNER** KEN CATO

**EVENT** DINOSAUR MUSEUM SHOW
**DESCRIPTION OF PIECE(S)** BANNERS,
BUS SHELTERS, T-SHIRTS
**DESIGN FIRM** MIKE QUON DESIGN OFFICE
**ART DIRECTOR** GRO FRUVOU
**DESIGNER** MIKE QUON
**ILLUSTRATOR** MIKE QUON

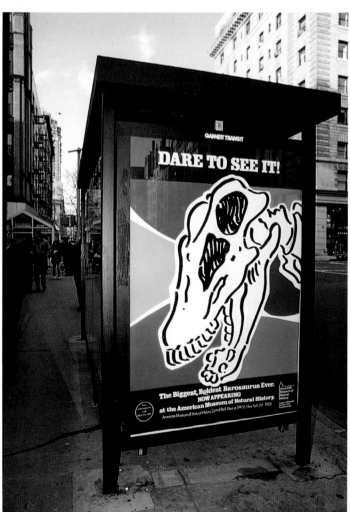

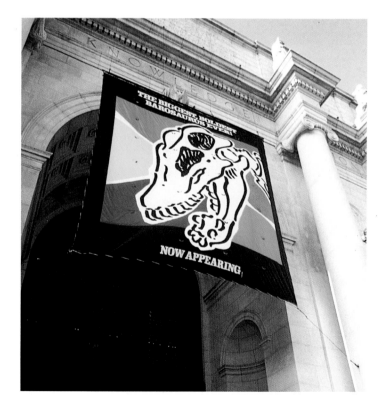

**EVENT** CELEBRATION OF FINE ARTS PROGRAM/
SOUTHWEST TEXAS STATE UNIVERSITY
**DESCRIPTION OF PIECE(S)** BROCHURE, POSTERS, PINS
**DESIGN FIRM** THE BRADFORD LAWTON DESIGN GROUP
**ART DIRECTOR** BRADFORD LAWTON, WILLIAM MEEK
**DESIGNER** BRADFORD LAWTON, JODY LANEY
**ILLUSTRATOR** BRADFORD LAWTON, JODY LANEY

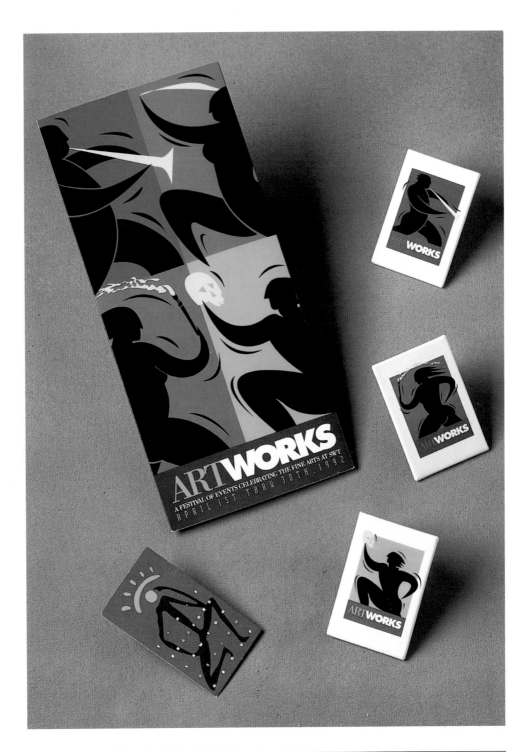

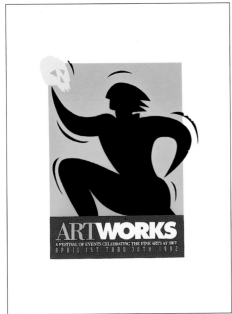

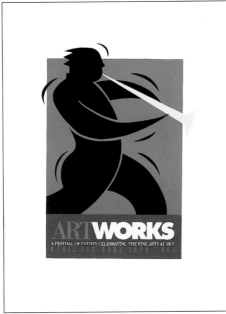

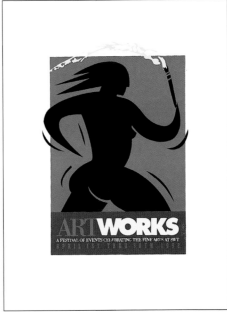

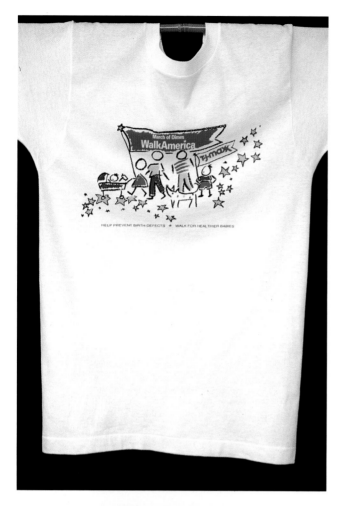

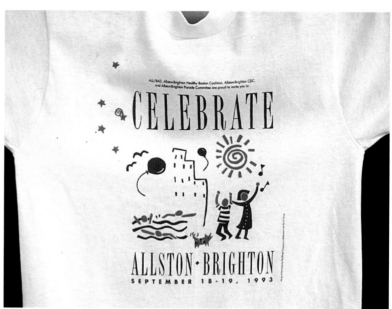

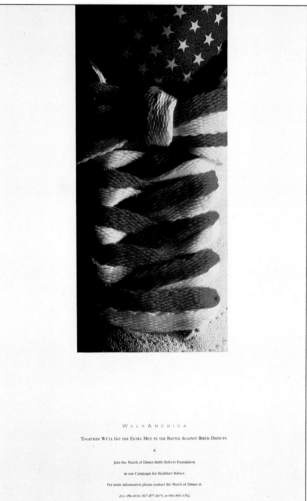

CLOCKWISE FROM TOP LEFT

**EVENT** MARCH OF DIMES WALK AMERICA CAMPAIGN
**DESCRIPTION OF PIECE(S)** T-SHIRT, BUTTON
**DESIGN FIRM** THE DESIGN COMPANY
**ART DIRECTOR** BUSHA HUSAK
**DESIGNER** BUSHA HUSAK
**ILLUSTRATOR** BUSHA HUSAK

**EVENT** CELEBRATE ALLSTON-BRIGHTON
**DESCRIPTION OF PIECE(S)** T-SHIRT
**DESIGN FIRM** THE DESIGN COMPANY
**ART DIRECTOR** BUSHA HUSAK
**DESIGNER** BUSHA HUSAK
**ILLUSTRATOR** BUSHA HUSAK

**EVENT** MARCH OF DIMES WALK-A-THON
**DESCRIPTION OF PIECE(S)** POSTER
**DESIGN FIRM** SULLIVANPERKINS
**ART DIRECTOR** RON SULLIVAN, LORRAINE CHARMAN
**DESIGNER** LORRAINE CHARMAN
**PHOTOGRAPHER** ROBB DEBENPORT
**COPYWRITER** DAVY WOODRUFF

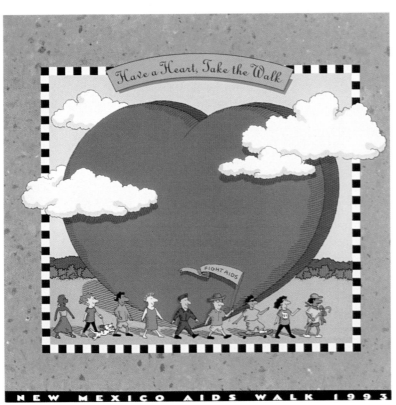

**NEW MEXICO AIDS WALK 1993**

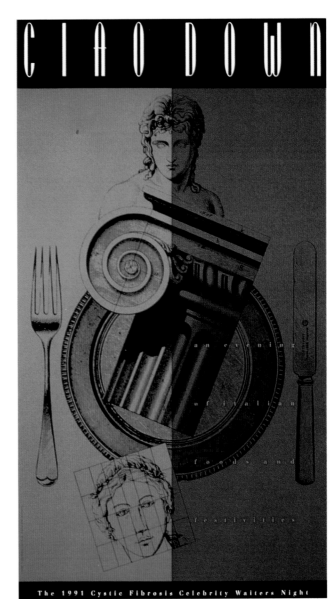

**CIAODOWN**

The 1991 Cystic Fibrosis Celebrity Waiters Night

CLOCKWISE FROM TOP LEFT

**EVENT** AIDS WALK
**DESCRIPTION OF PIECE(S)** POSTER
**DESIGN FIRM** VAUGHN WEDEEN CREATIVE
**ART DIRECTOR** RICK VAUGHN
**DESIGNER** LISA GRAFF
**ILLUSTRATOR** LISA GRAFF

**EVENT** "CIAO DOWN"/FUNDRAISER DINNER
**DESCRIPTION OF PIECE(S)** POSTER
**DESIGN FIRM** VAUGHN WEDEEN CREATIVE
**ART DIRECTOR** STEVE WEDEEN
**DESIGNER** STEVE WEDEEN

PRO BONO POSTER FOR CYSTIC FIBROSIS FOUNDATION.

**EVENT** "AIDS/HIV LIFE CENTER"
**DESCRIPTION OF PIECE(S)** VALENTINE INVITATION
**DESIGN FIRM** SACKETT DESIGN ASSOCIATES
**ART DIRECTOR** MARK SACKETT
**DESIGNER** MARK SACKETT, WAYNE SAKAMOTO
**ILLUSTRATOR** VARIOUS

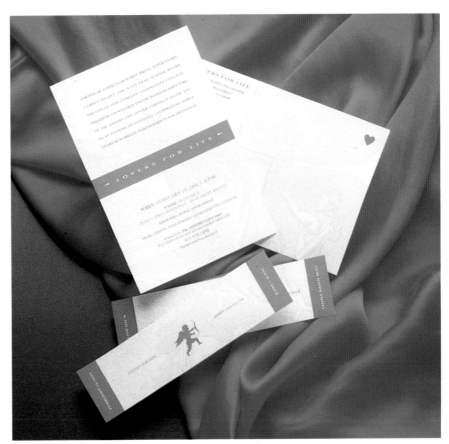

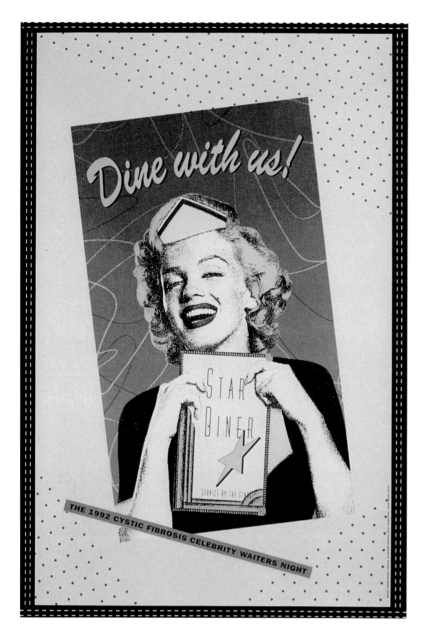

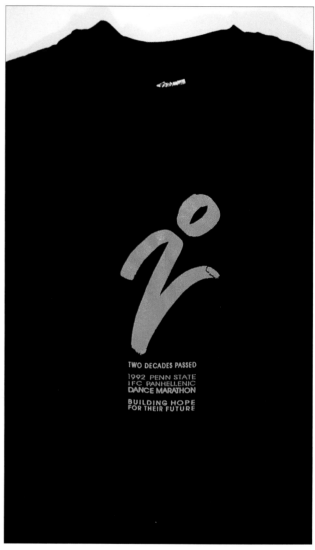

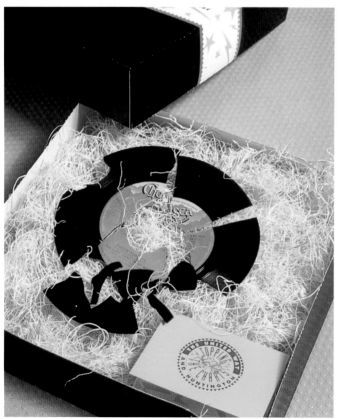

CLOCKWISE FROM TOP LEFT

**Event** "Dine With Us!"/Fundraiser Dinner
**Description of Piece(s)** Poster
**Design Firm** Vaughn Wedeen Creative
**Art Director** Rick Vaughn
**Designer** Rick Vaughn
**Illustrator** Rick Vaughn

**Event** 20th Annual Dance Marathon
**Description of Piece(s)** T-shirt
**Design Firm** Sommese Design
**Art Director** Kristin Sommese
**Designer** Jim Lilly

Annual student event raises over $1 million each
year for children with cancer.

**Event** "Topping the Charts" Party/Huntington Banks
United Way Campaign
**Description of Piece(s)** Incentive gift box, box tag,
annoucement "record", letterhead
**Design Firm** Rickabaugh Graphics
**Art Director** Eric Rickabaugh
**Designer** Tina Zientarski
**Illustrator** Michael Linley

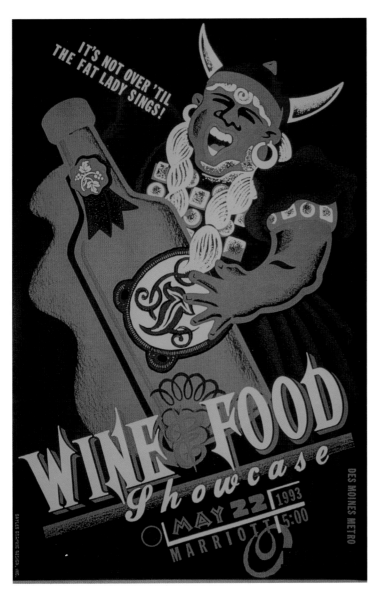

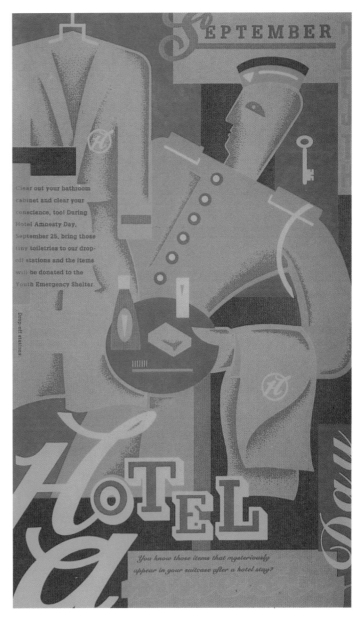

CLOCKWISE FROM TOP LEFT

**EVENT** "WINE & FOOD SHOWCASE"
**DESCRIPTION OF PIECE(S)** POSTER
**DESIGN FIRM** SAYLES GRAPHIC DESIGN
**ART DIRECTOR** JOHN SAYLES
**DESIGNER** JOHN SAYLES

THIS EVENT WAS A BENEFIT FOR A LOCAL OPERA.

**EVENT** "HOTEL AMNESTY DAY"
**DESCRIPTION OF PIECE(S)** POSTER
**DESIGN FIRM** SAYLES GRAPHIC DESIGN
**ART DIRECTOR** JOHN SAYLES
**DESIGNER** JOHN SAYLES

THIS FUNDRAISING EVENT ALLOWED DONORS TO
GIVE ITEMS "BORROWED" FROM HOTELS.

**EVENT** "MARCH OF DIMES BID FOR BACHELORS"
**DESCRIPTION OF PIECE(S)** POSTER,
BROCHURE, TICKETS
**DESIGN FIRM** SACKETT DESIGN ASSOCIATES
**ART DIRECTOR** MARK SACKETT
**DESIGNER** MARK SACKETT, WAYNE SAKAMOTO
**ILLUSTRATOR** MARK SACKETT,
WAYNE SAKAMOTO

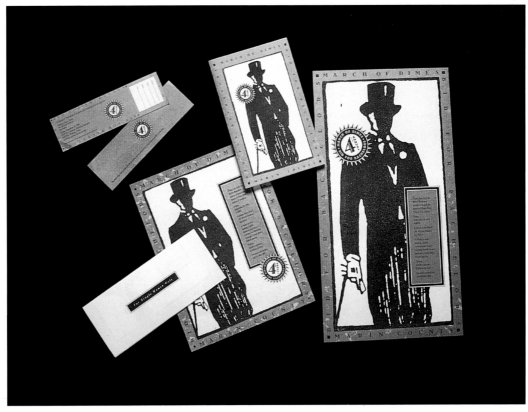

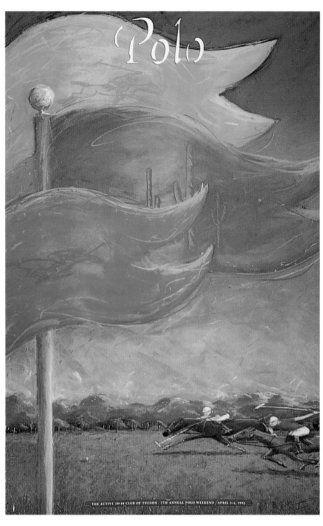

**EVENT** TUCSON POLO EVENT
**DESCRIPTION OF PIECE(S)** POSTER AND COLLATERAL
**DESIGN FIRM** BOELTS BROS. DESIGN INC.
**ART DIRECTOR** JACKSON BOELTS, ERIC BOELTS
**DESIGNER** JACKSON BOELTS, ERIC BOELTS,
 KERRY STRATFORD
**ILLUSTRATOR** ERIC BOELTS

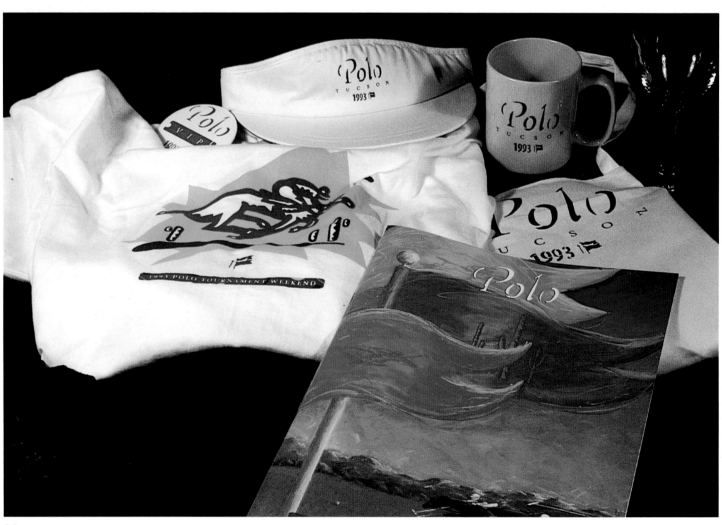

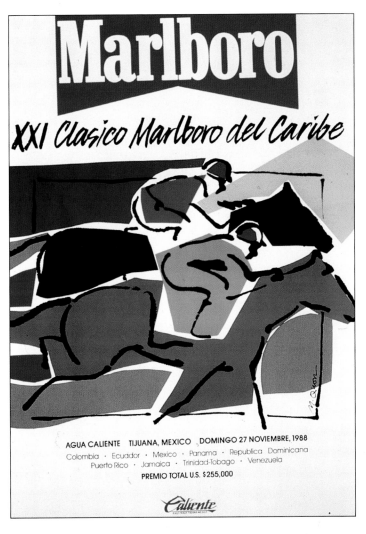

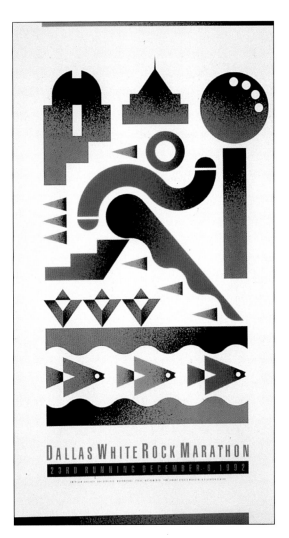

**EVENT** MARLBORO HORSE RACE
**DESCRIPTION OF PIECE(S)** POSTER
**DESIGN FIRM** MIKE QUON DESIGN OFFICE
**ART DIRECTOR** ALAN MOGEL
**DESIGNER** MIKE QUON
**ILLUSTRATOR** MIKE QUON

**EVENT** WHITE ROCK MARATHON
**DESCRIPTION OF PIECE(S)** POSTER
**DESIGN FIRM** SIBLEY/PETEET
**ART DIRECTOR** JOHN EVANS
**DESIGNER** JOHN EVANS
**ILLUSTRATOR** JOHN EVANS

**EVENT** CHICAGO SUN TIMES TRIATHLON
**DESCRIPTION OF PIECE(S)** LOGO
**DESIGN FIRM** JIM LANGE DESIGN
**ART DIRECTOR** JAN LANGE
**DESIGNER** JIM LANGE
**ILLUSTRATOR** JIM LANGE

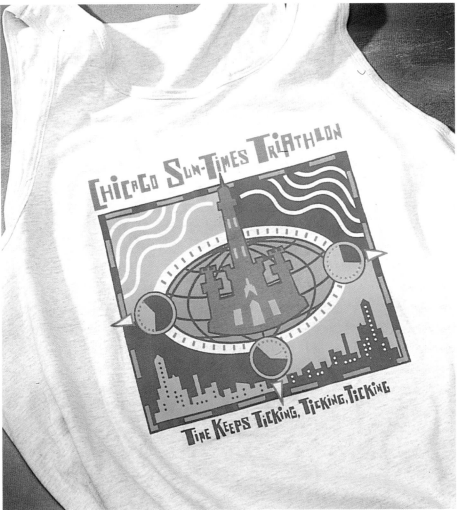

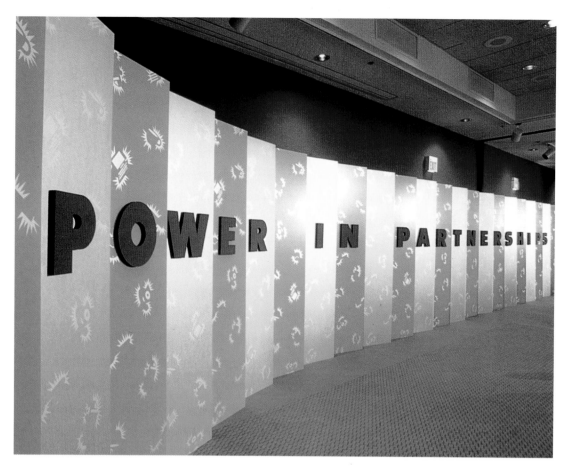

**EVENT** "BOLDLY INTO TOMORROW"/FOOD SERVICES OF AMERICA CONFERENCE
**DESCRIPTION OF PIECE(S)** INVITATION, EXHIBIT
**DESIGN FIRM** HORNALL ANDERSON DESIGN WORKS
**ART DIRECTOR** JACK ANDERSON
**DESIGNER** JACK ANDERSON, JANI DREWFS, CLIFF CHUNG, BRIAN O'NEILL

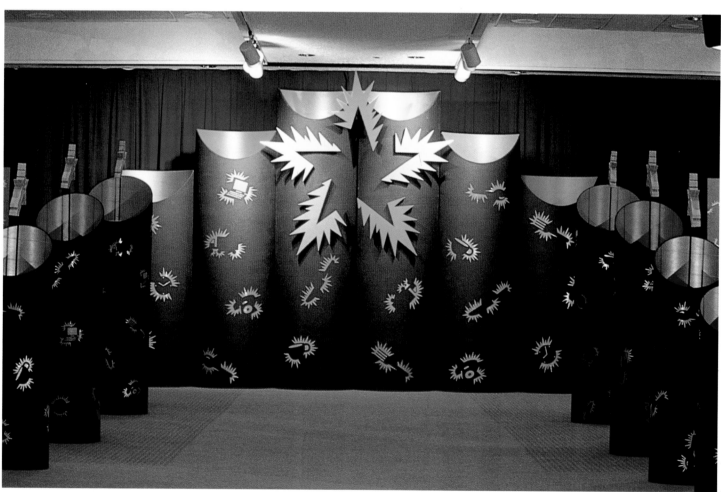

**EVENT** "POWER IN PARTNERSHIP"/FOOD SERVICES OF AMERICA CONFERENCE
**DESCRIPTION OF PIECE(S)** CONFERENCE SIGNAGE
**DESIGN FIRM** HORNALL ANDERSON DESIGN WORKS
**ART DIRECTOR** JACK ANDERSON
**DESIGNER** JACK ANDERSON, CLIFF CHUNG, SCOTT EGGERS, DAVID BATES

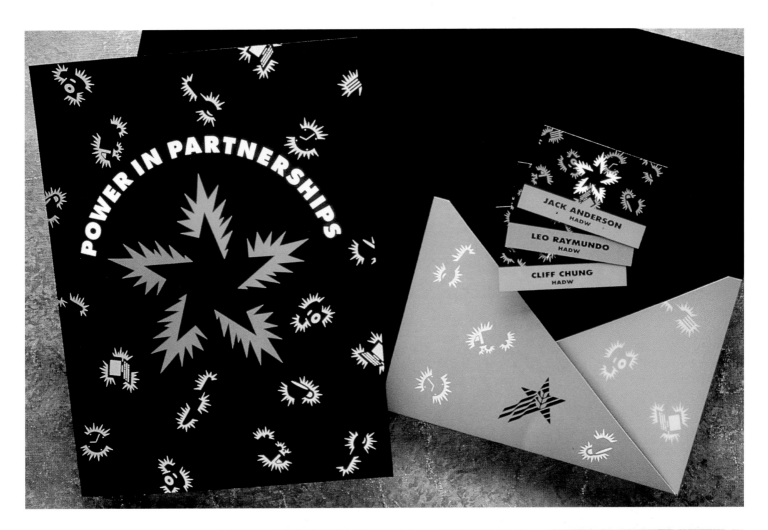

**Event** "Power in Partnership"/Food
Services of America Conference
**Description of Piece(s)** Conference signage
**Design Firm** Hornall Anderson
Design Works
**Art Director** Jack Anderson
**Designer** Jack Anderson, Cliff Chung,
Scott Eggers, David Bates

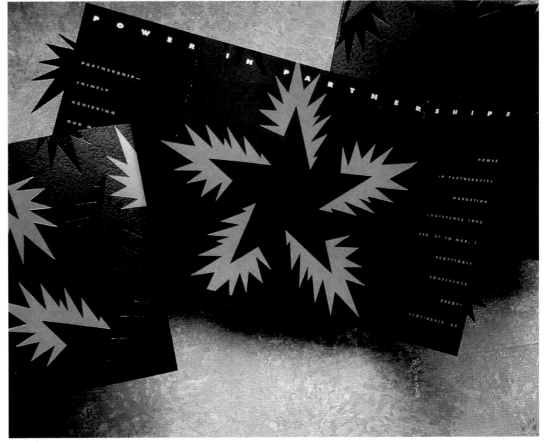

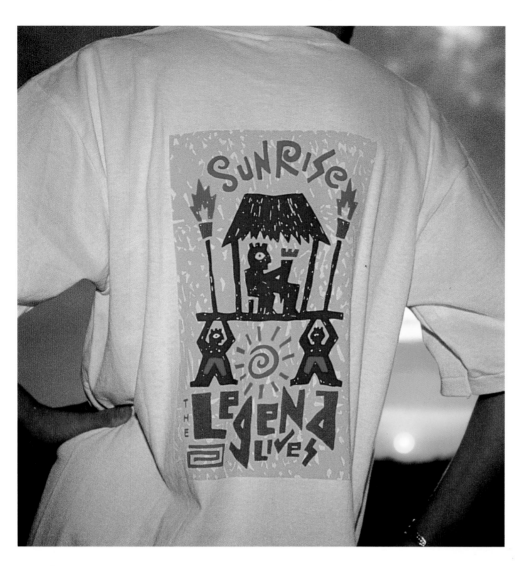

**Event** "The Legend Lives"/Corporate Event
**Description of Piece(s)** T-shirt
**Design Firm** Sayles Graphic Design
**Art Director** John Sayles
**Designer** John Sayles

Graphics were developed to reflect the meeting location: Maui.

**Event** "Presidents Club Cruise"/Sales Event
**Description of Piece(s)** Gifts and amenities
**Design Firm** Sayles Graphic Design
**Art Director** John Sayles
**Designer** John Sayles

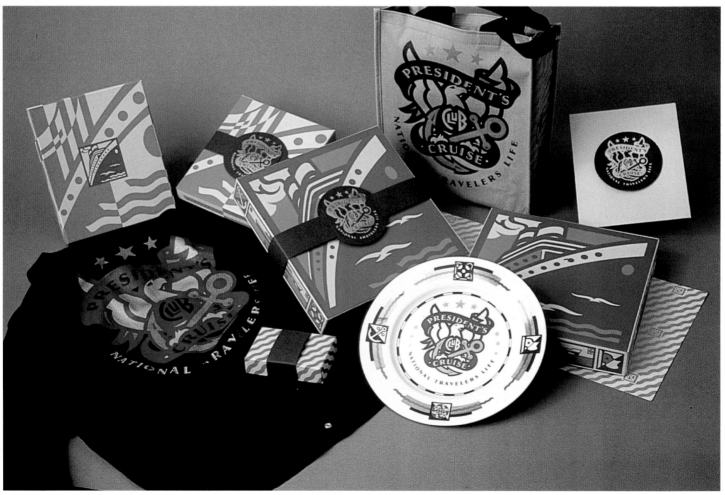

**EVENT** MOTOROLLA AWARDS NIGHT
**DESCRIPTION OF PIECE(S)** INVITATION, AWARD
**DESIGN FIRM** JON FLAMING DESIGN
**ART DIRECTOR** DIDI STUART
**DESIGNER** JOHN EVANS/ JOHN EVANS DESIGN
**ILLUSTRATOR** JOHN EVANS
**AGENCY** SICOLA/MARTIN

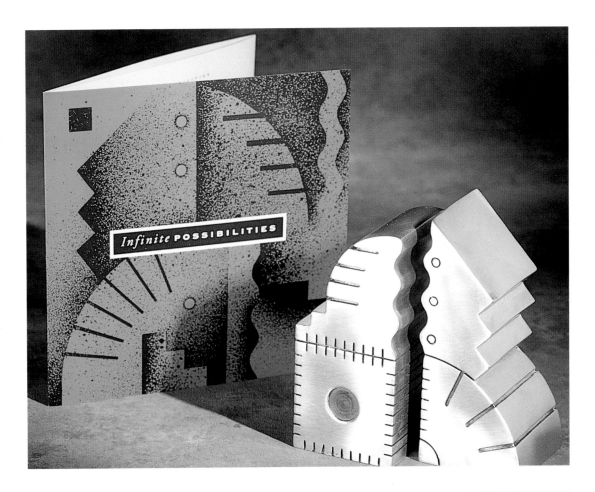

**EVENT** "A TIME OF CHANGE"/ FINANCIAL SEMINAR
**DESCRIPTION OF PIECE(S)** MAILER AND COLLATERAL
**DESIGN FIRM** SAYLES GRAPHIC DESIGN
**ART DIRECTOR** JOHN SAYLES
**DESIGNER** JOHN SAYLES

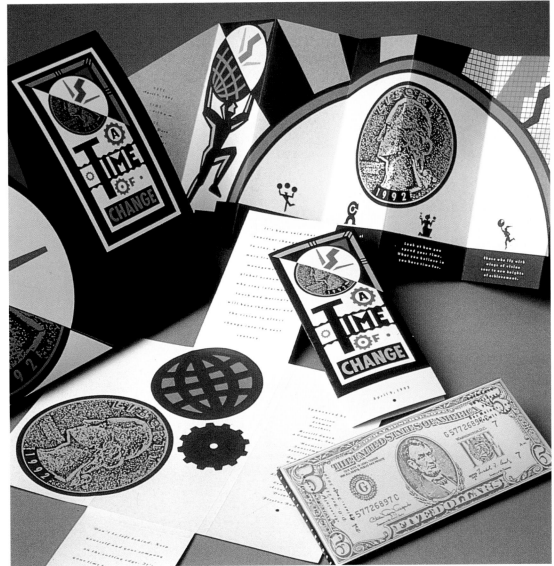

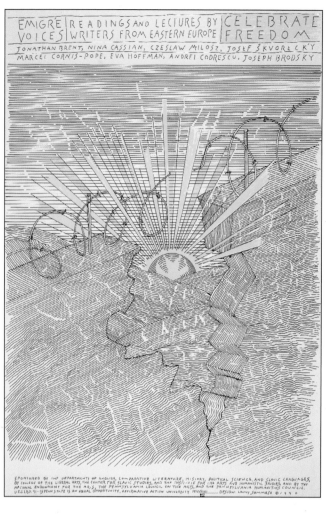

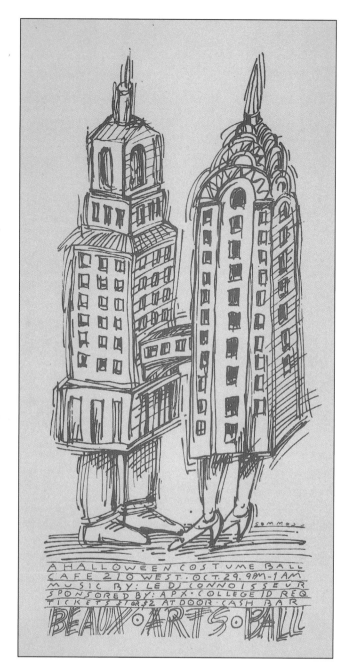

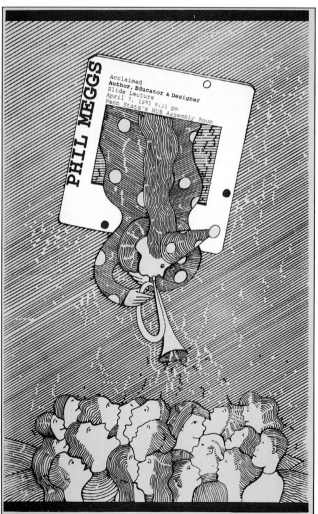

CLOCKWISE FROM TOP LEFT

**EVENT** LECTURE SERIES
**DESCRIPTION OF PIECE(S)** POSTER
**DESIGN FIRM** SOMMESE DESIGN
**ART DIRECTOR** LANNY SOMMESE
**DESIGNER** LANNY SOMMESE

LECTURE SERIES WAS MADE UP OF WRITERS
FROM EASTERN EUROPE.

**EVENT** COSTUME BALL FOR ARCHITECTURE STUDENTS
**DESCRIPTION OF PIECE(S)** POSTER (SILKSCREEN)
**DESIGN FIRM** SOMMESE DESIGN
**ART DIRECTOR** LANNY SOMMESE
**DESIGNER** LANNY SOMMESE
**ILLUSTRATOR** LANNY SOMMESE

**EVENT** PHIL MEGGS LECTURE
**DESCRIPTION OF PIECE(S)** POSTER (SILKSCREEN)
**DESIGN FIRM** SOMMESE DESIGN
**ART DIRECTOR** LANNY SOMMESE
**DESIGNER** LANNY SOMMESE
**ILLUSTRATOR** LANNY SOMMESE

LECTURER IS AN EXPERT ON GRAPHIC DESIGN HISTORY.

**EVENT** SEYMOUR CHWAST LECTURE
**DESCRIPTION OF PIECE(S)** POSTER (SILKSCREEN)
**DESIGN FIRM** SOMMESE DESIGN
**ART DIRECTOR** LANNY SOMMESE

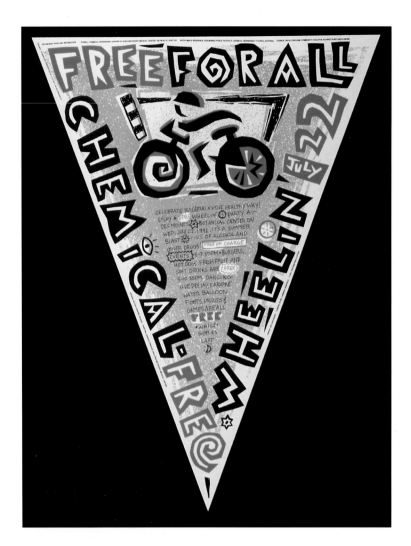

**EVENT** "Free For All"/Chemical-Free Party
**DESCRIPTION OF PIECE(S)** Poster, T-shirt
**DESIGN FIRM** Sayles Graphic Design
**ART DIRECTOR** John Sayles
**DESIGNER** John Sayles

All copy was hand rendered.

**Event** *"Frontline"/Church Youth Event*
**Description of Piece(s)** Poster,
collateral, jacket, flag
**Design Firm** Sayles Graphic Design
**Art Director** John Sayles
**Designer** John Sayles

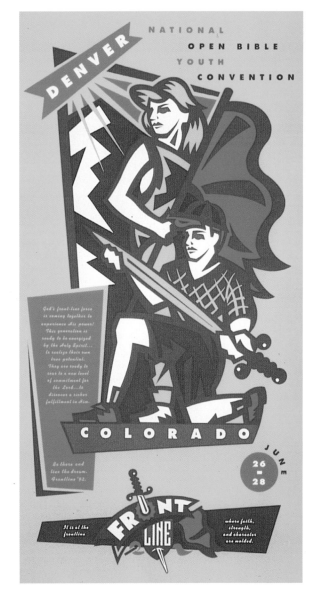

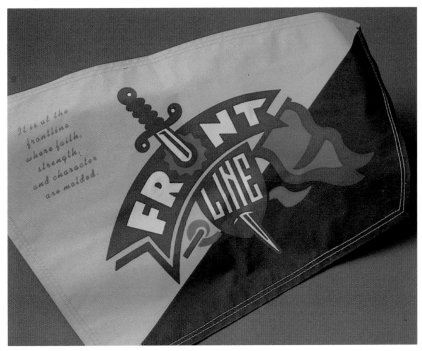

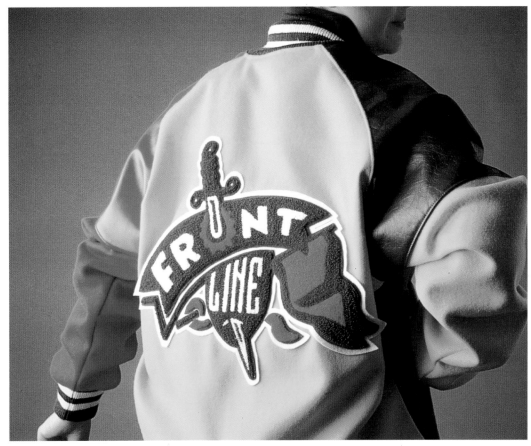

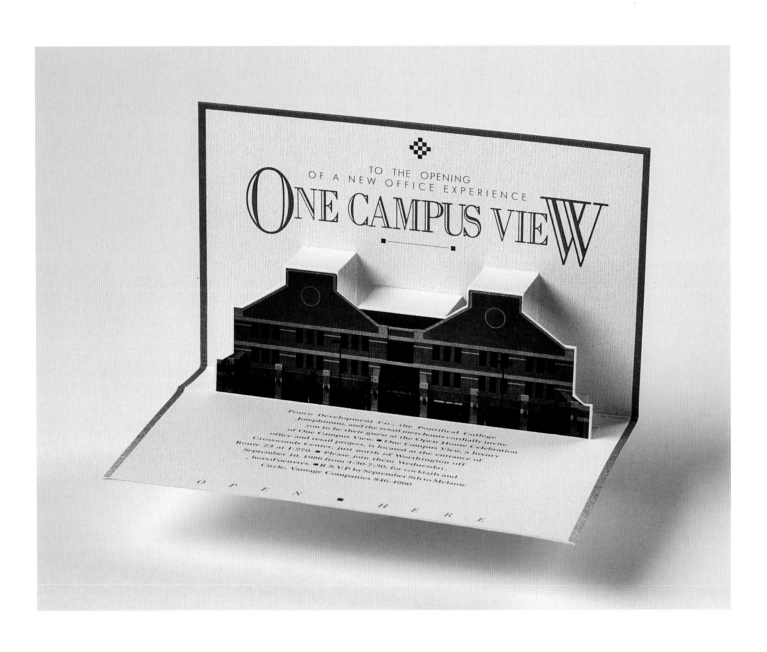

**Event** Open House
**Design Firm** Rickabaugh Graphics
**Art Director** Eric Rickabaugh
**Designer** Eric Rickabaugh
**Photographer** Tom Watson
**Client** Vantage Companies

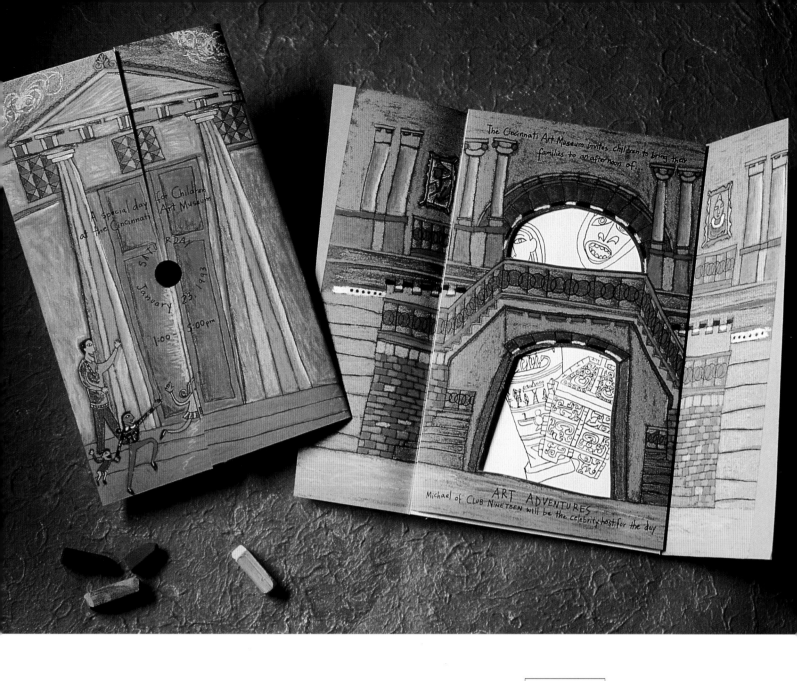

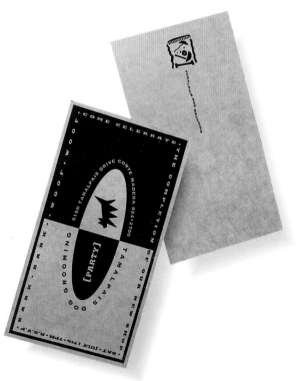

FROM TOP

**Event** Family Day Museum Opening
**Design Firm** Siebert Design Associates
**Art Director** Lori Siebert
**Designer** Lori Siebert
**Illustrator** Lori Siebert
**Client** Cincinnati Art Museum

**Event** Re-Opening Celebration
**Design Firm** WS Design
**Art Director** Wayne Sakamoto
**Designer** Wayne Sakamoto
**Client** Tamalpais Dog Grooming

33

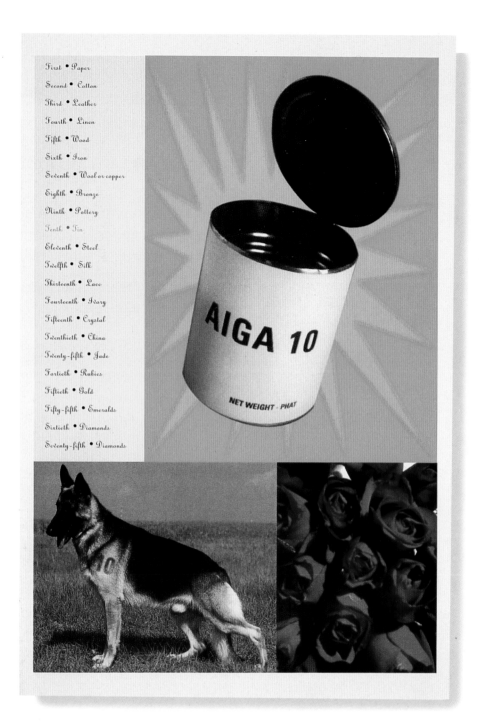

First • Paper
Second • Cotton
Third • Leather
Fourth • Linen
Fifth • Wood
Sixth • Iron
Seventh • Wool or copper
Eighth • Bronze
Ninth • Pottery
Tenth • Tin
Eleventh • Steel
Twelfth • Silk
Thirteenth • Lace
Fourteenth • Ivory
Fifteenth • Crystal
Twentieth • China
Twenty-fifth • Jade
Fortieth • Rubies
Fiftieth • Gold
Fifty-fifth • Emeralds
Sixtieth • Diamonds
Seventy-fifth • Diamonds

**AIGA 10**

NET WEIGHT - PHAT

**EVENT** A.I.G.A./BOSTON 10TH ANNIVERSARY BASH
**DESIGN FIRM** FARENHEIT
**ART DIRECTOR** CAROLYN MONTIE, PAUL MONTIE
**DESIGNER** PAUL MONTIE, CAROLYN MONTIE
**PHOTOGRAPHER** KENT DAYTON
**CLIENT** A.I.G.A./BOSTON

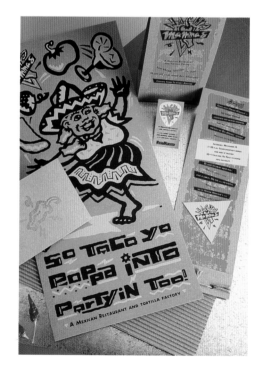

**EVENT** RESTAURANT GRAND OPENING
**DESIGN FIRM** SAYLES GRAPHIC DESIGN
**ART DIRECTOR** JOHN SAYLES
**DESIGNER** JOHN SAYLES
**ILLUSTRATOR** JOHN SAYLES
**CLIENT** NACHO MAMMAS

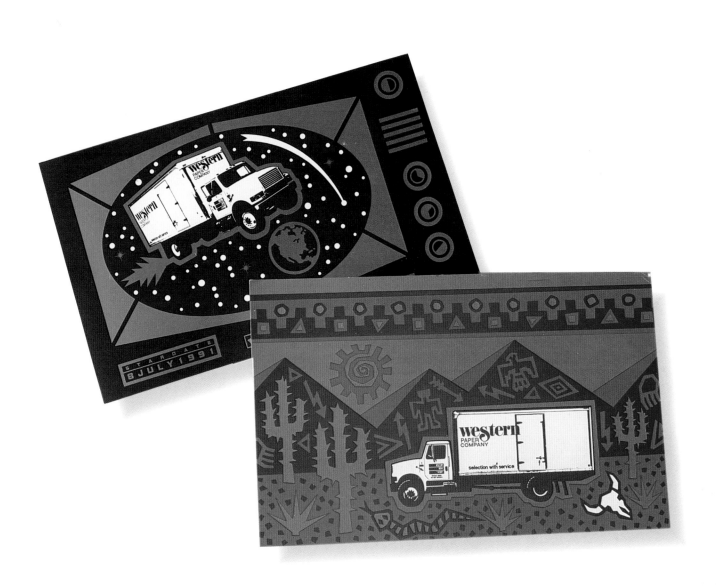

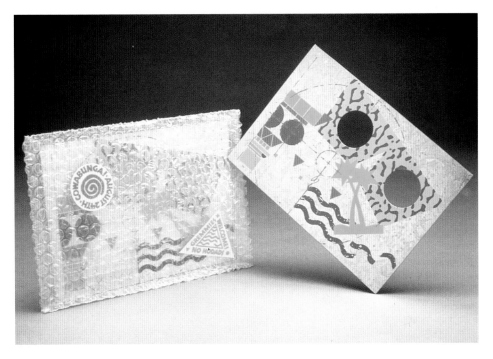

FROM TOP

**Event** Moving Announcement
**Design Firm** New Idea Design, Inc.
**Designer** Ron Boldt
**Illustrator** Ron Boldt
**Client** Western Paper Company

**Event** Moving/Open House Announcement
**Design Firm** Hornall Anderson Design Works
**Art Director** John Hornall, Jack Anderson
**Designer** John Hornall, Jack Anderson, Julie Tanagi-Lock
**Client** Hornall Anderson Design Works

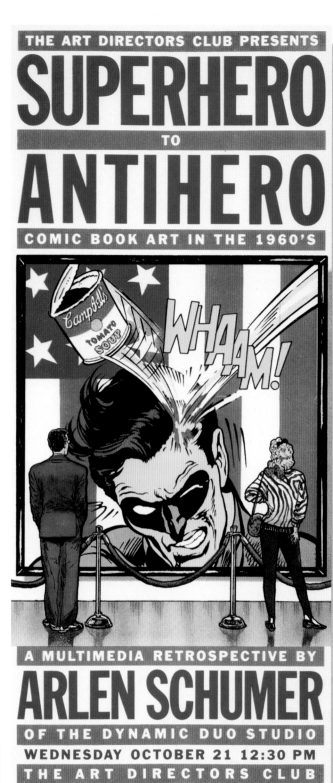

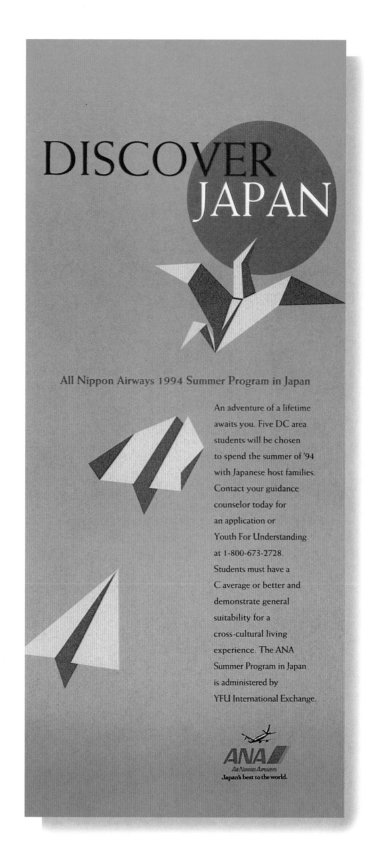

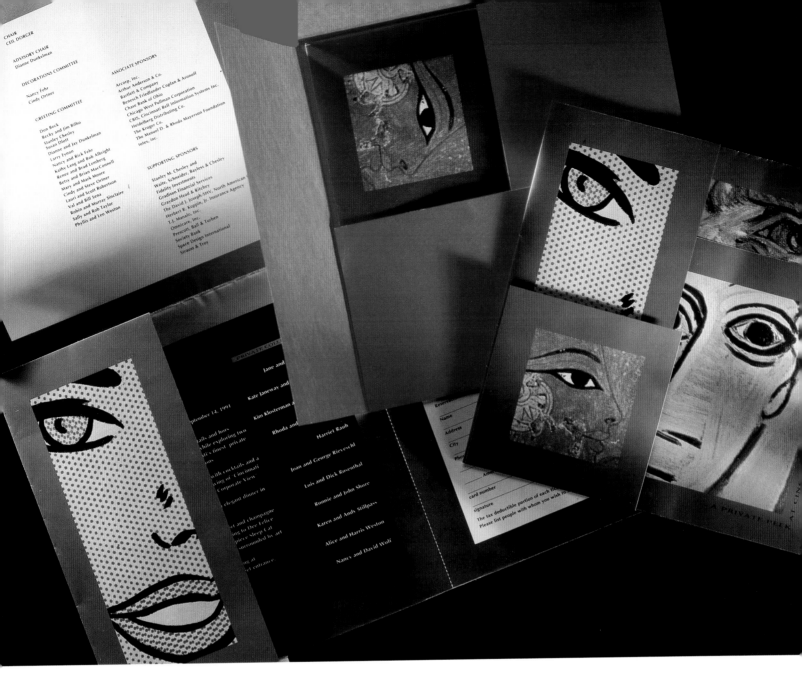

CLOCKWISE FROM FAR LEFT

**EVENT** MULTI-PROJECTOR SLIDE SHOW/
    LECTURE AT THE NEW YORK ART
    DIRECTORS CLUB
**DESIGN FIRM** THE DYNAMIC DUO, INC.
**ART DIRECTOR** ARLEN SCHUMER
**DESIGNER** ARLENE SCHUMER
**ILLUSTRATOR** THE DYNAMIC DUO, INC.
**DESIGN & LINE ART** ARLEN SCHUMER
**COLOR** SHERRI WOLFGANG
**CLIENT** SELF PROMOTIONAL
GREEN LANTERN © D.C. COMICS 1970

**EVENT** ANNOUNCEMENT FOR JAPAN TRIP
**DESIGN FIRM** SUPON DESIGN GROUP, INC.
**ART DIRECTOR** ANDREW DOLAN, SUPON
    PHORNIRUNLIT
**DESIGNER** ANDREW DOLAN
**ILLUSTRATOR** **ANDREW DOLAN**
**CLIENT** ALL NIPPON AIRWAYS

**EVENT** FUNDRAISER
**DESIGN FIRM** SIEBERT DESIGN
    ASSOCIATES
**ART DIRECTOR** LORI SIEBERT
**DESIGNER** DIANE SULLIVAN
**ILLUSTRATOR** VARIOUS
**CLIENT** CONTEMPORARY ARTS CENTER

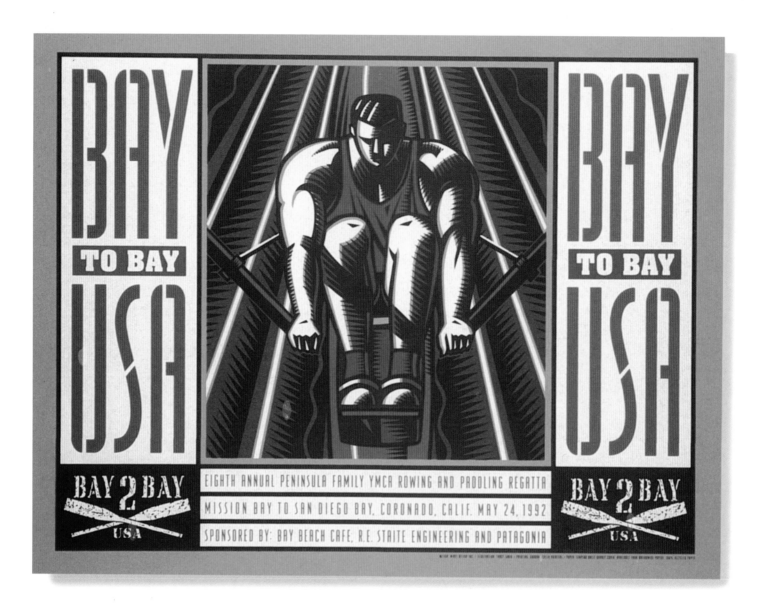

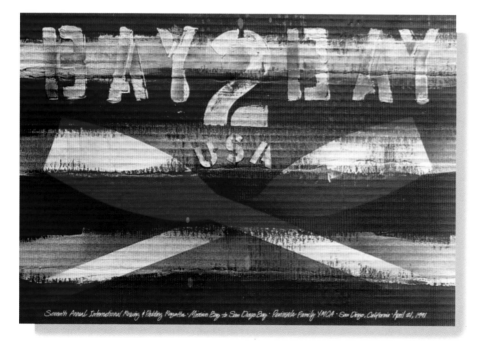

FROM TOP

**Event** Rowing Regatta Announcement
**Design Firm** Mires Design, Inc.
**Art Director** Jóse Serrano
**Designer** Jóse Serrano
**Illustrator** Tracy Sabin
**Client** Peninsula

**Event** Rowing Regatta
**Design Firm** Mires Design, Inc.
**Art Director** Jóse Serrano
**Designer** Jóse Serrano
**Illustrator** Gerald Bustamante
**Client** Peninsula Family YMCA

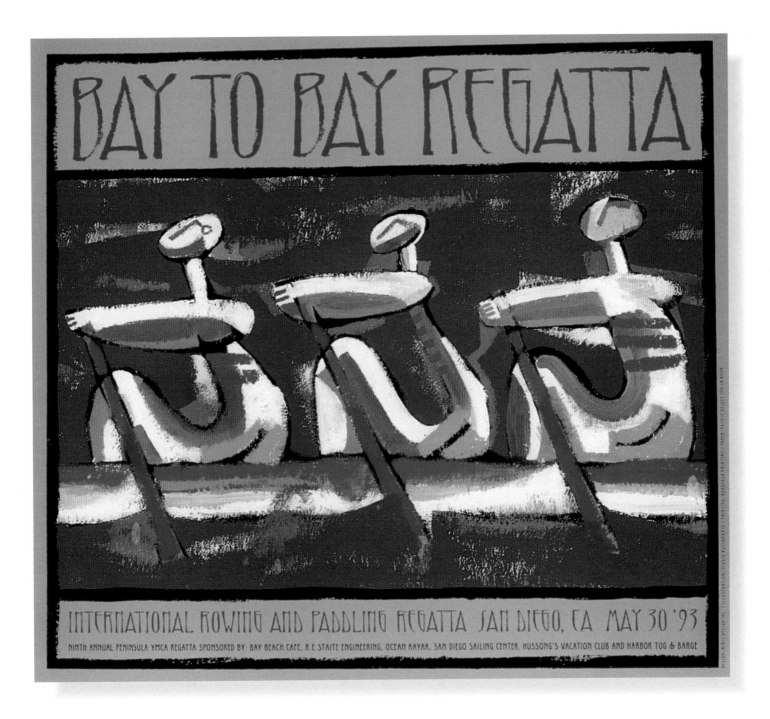

**Event** Rowing Regatta
**Design Firm** Mires Design, Inc.
**Art Director** José Serrano
**Designer** José Serrano
**Illustrator** Gerald Bustamante
**Client** Peninsula Family YMCA

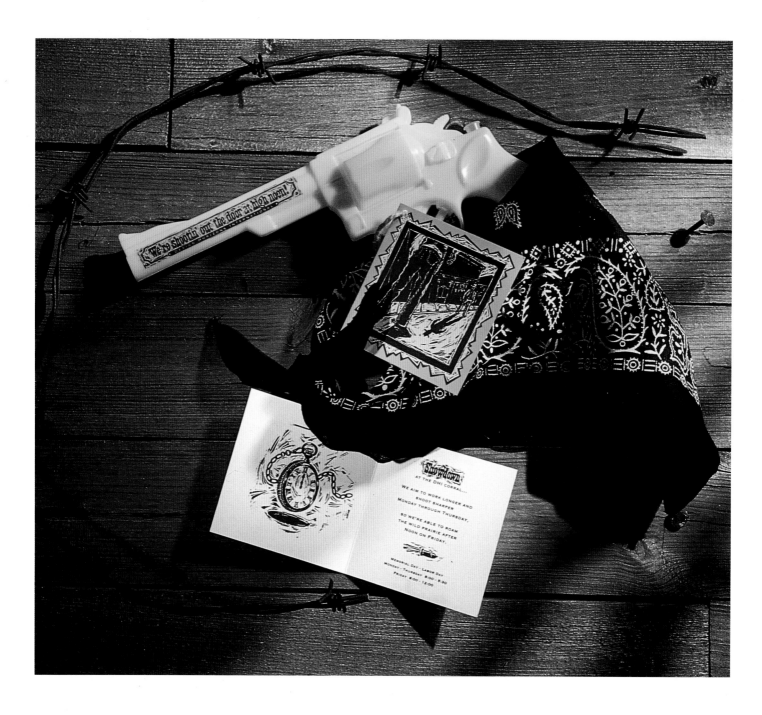

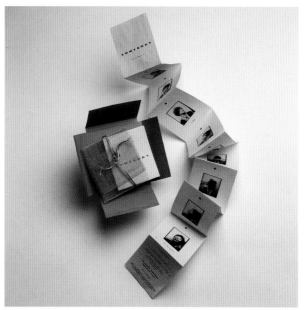

FROM TOP

**EVENT** SUMMER PROMOTION
**DESIGN FIRM** DESIGN HORIZONS INTERNATIONAL
**ART DIRECTOR** BRYANN SANZOTTI
**DESIGNER** JANAN CAIN
**ILLUSTRATOR** JANAN CAIN
**CLIENT** DESIGN HORIZONS INTERNATIONAL

**EVENT** GRAPHIC DESIGNER'S PROMOTION
**DESIGN FIRM** HEATHER ROBINET
**DESIGNER** HEATHER ROBINET

**EVENT** ANNOUNCE NEW WATCHES
**DESIGN FIRM** CHARLES S. ANDERSON DESIGN CO.
**ART DIRECTOR** CHARLES S. ANDERSON
**DESIGNER** CHARLES S. ANDERSON, JENNIFER BAER
**ILLUSTRATOR** CSA ARCHIVE
**CLIENT** CHARLES S. ANDERSON DESIGN CO.

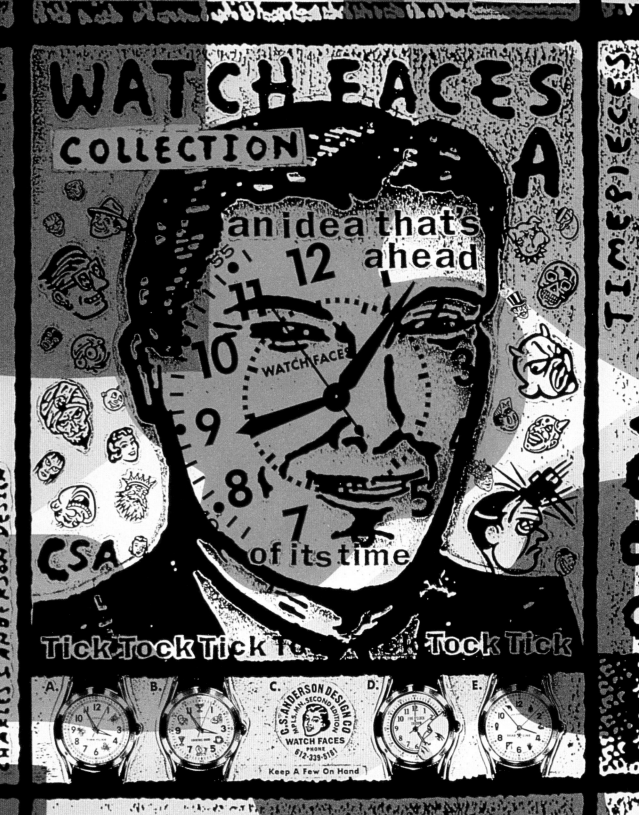

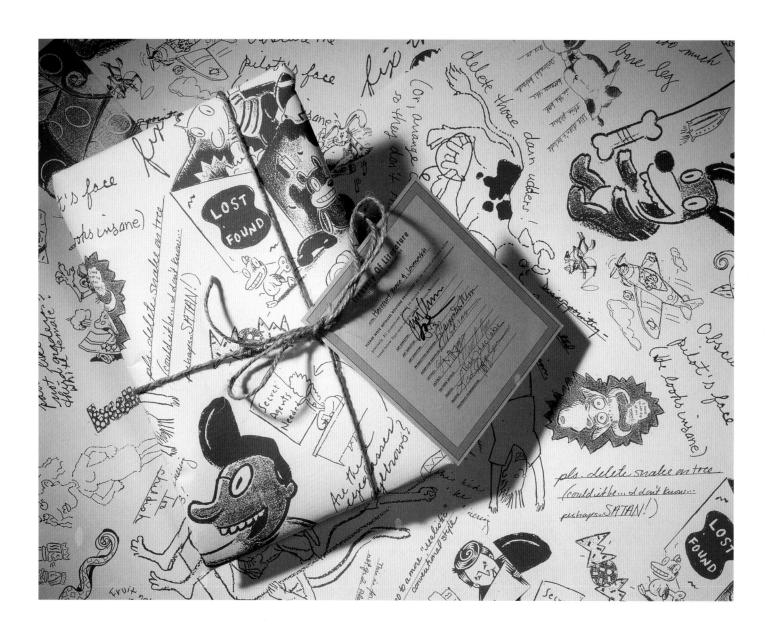

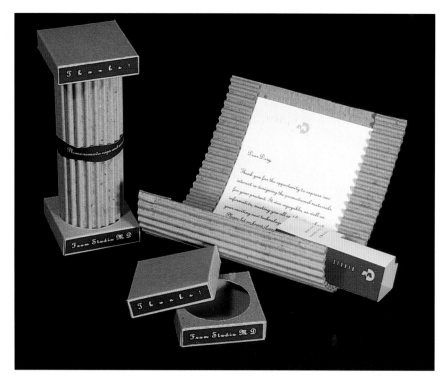

FROM TOP

**Event** Promotional
**Design Firm** Mires Design, Inc.
**Art Director** Mires Design, Inc.
**Designer** Scott Mires
**Client** Harcourt Brace & Jovanovich

**Event** Thank You Cards
**Design Firm** Studio MD
**Art Director** Jesse Doquilo, Randy Lim,
    Glenn Mitsui
**Designer** Jesse Doquilo
**Client** Studio MD

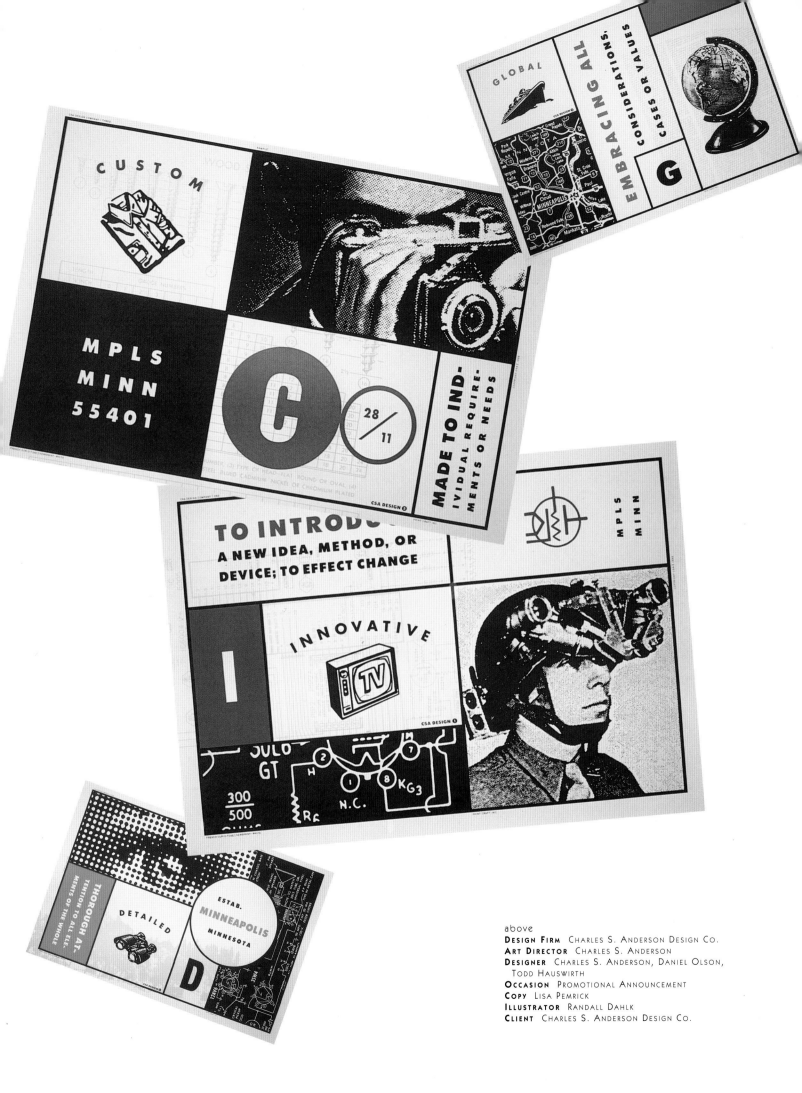

above
**DESIGN FIRM** CHARLES S. ANDERSON DESIGN CO.
**ART DIRECTOR** CHARLES S. ANDERSON
**DESIGNER** CHARLES S. ANDERSON, DANIEL OLSON, TODD HAUSWIRTH
**OCCASION** PROMOTIONAL ANNOUNCEMENT
**COPY** LISA PEMRICK
**ILLUSTRATOR** RANDALL DAHLK
**CLIENT** CHARLES S. ANDERSON DESIGN CO.

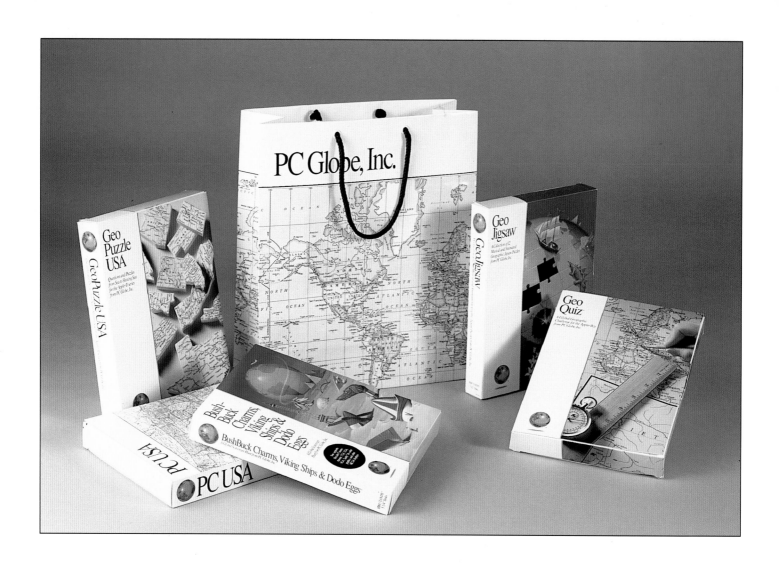

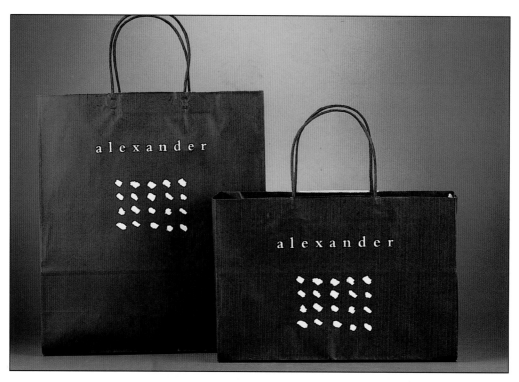

FROM TOP

**Design Firm** Richardson or Richardson
**Art Director** Forrest Richardson
**Designer** Debi Young Mees
**Client/Store** PC Gobe, Inc.

**Design Firm** Gregory Group, Inc.
**Art Director** Jon Gregory
**Designer** Jon Gregory
**Client/Store** Alexander

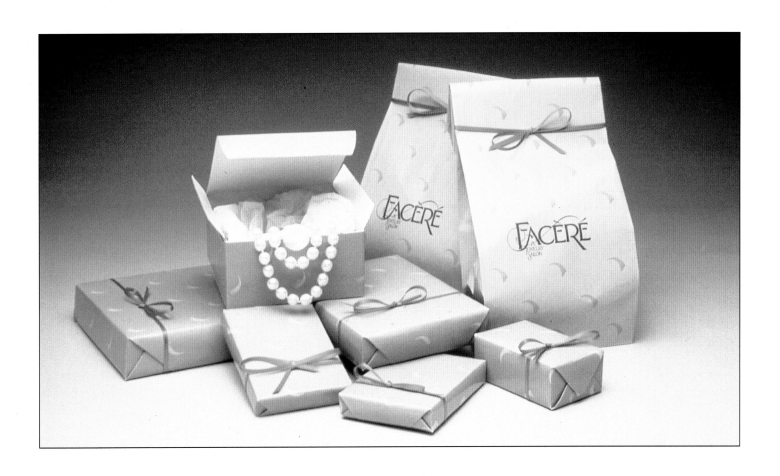

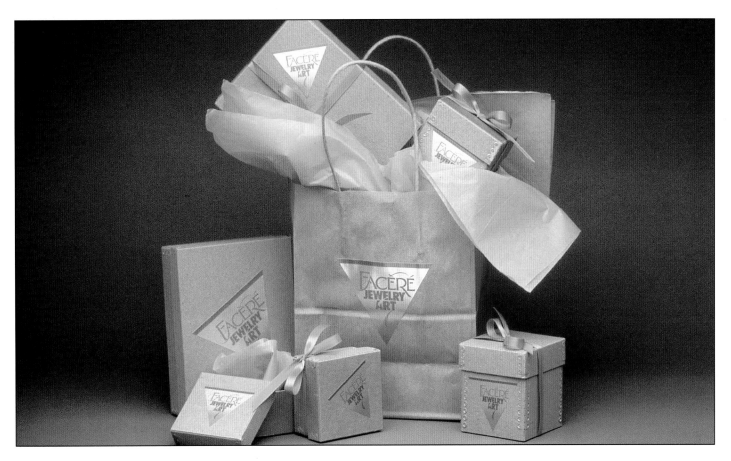

FROM TOP

**DESIGN FIRM** HORNALL ANDERSON DESIGN WORKS
**ART DIRECTOR** JACK ANDERSON
**DESIGNER** JACK ANDERSON/JULIET SHEN
**ILLUSTRATOR/ARTIST** BRUCE HALE
**CLIENT/STORE** FACERE JEWELRY ART

45

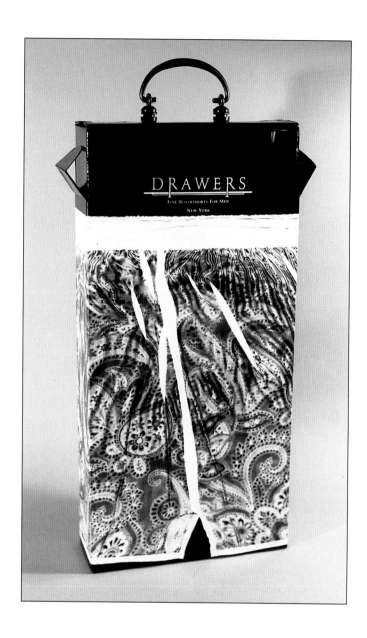

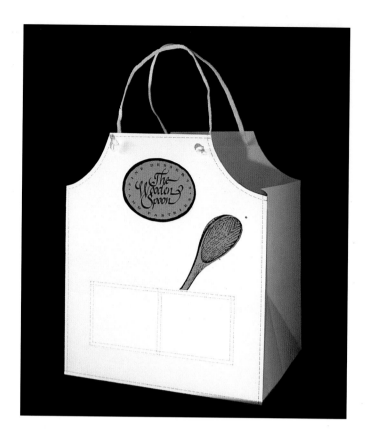

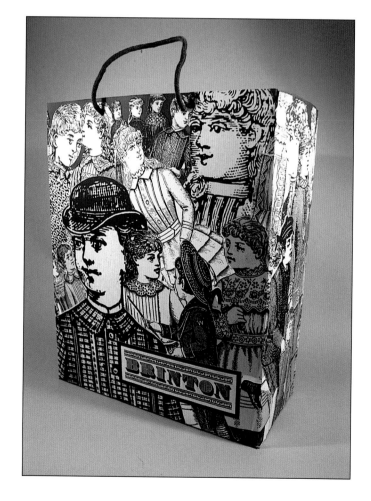

**Design Firm** Art 497.1—Penn State University
**Art Director** Kristin Sommese
**Designer** Brian Hatcher
**Photographer** Brian Hatcher
**Client/Store** Drawers (Men's Lingerie Store)

**Design Firm** Art 497.1—Penn State University
**Art Director** Kristin Sommese
**Designer** Lee Miller
**Client/Store** The Wooden Spoon (Bakery)

**Design Firm** Art 497.1—Penn State University
**Art Director** Kristin Sommese
**Designer** Mark Brinton
**Client/Store** Brinton (Antique Clothing Shop)

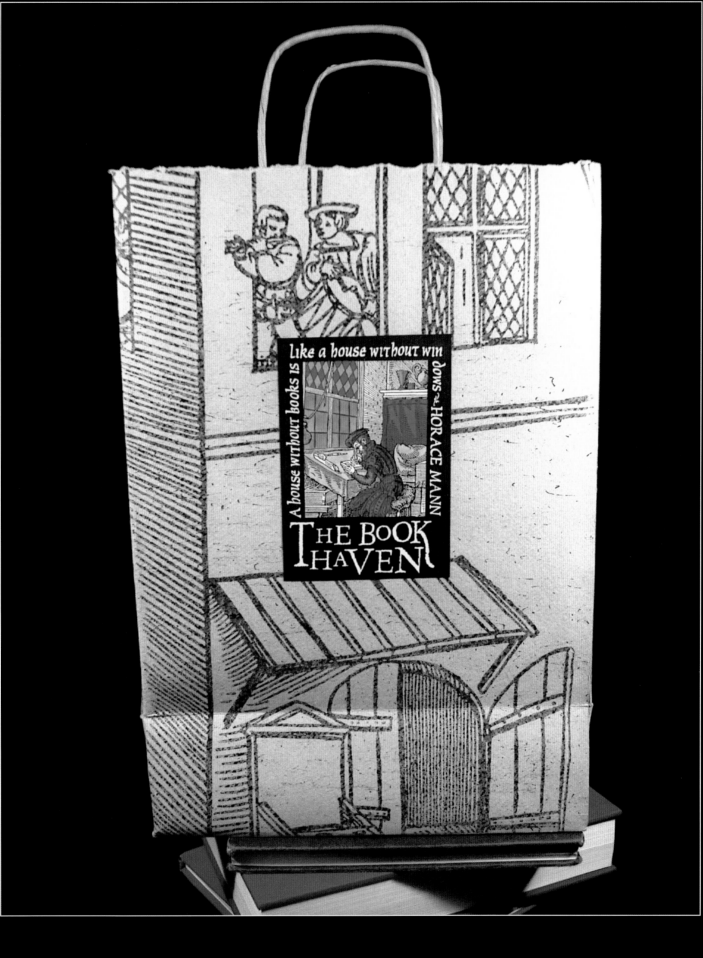

**DESIGN FIRM** ART 497.1—PENN STATE UNIVERSITY
**ART DIRECTOR** KRISTIN SOMMESE
**DESIGNER** BETHANY BOWLES
**CLIENT/STORE** THE BOOK HAVEN

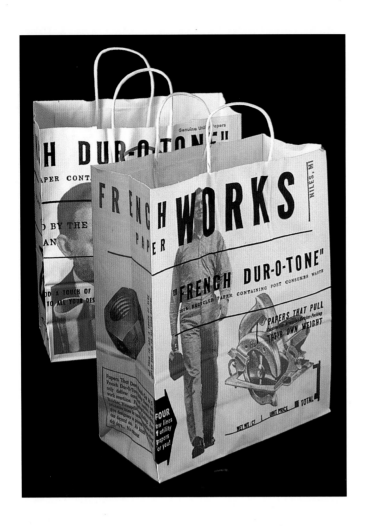

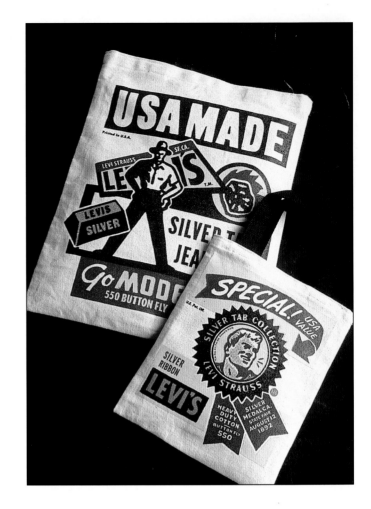

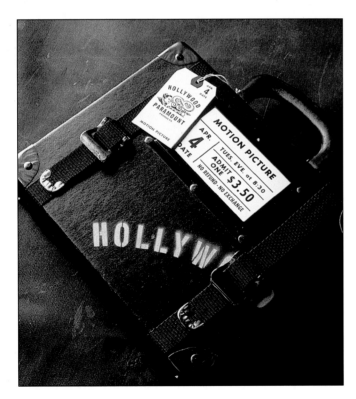

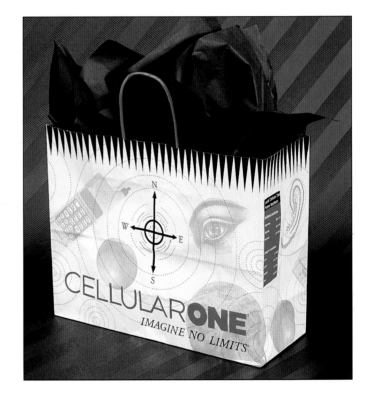

CLOCKWISE FROM TOP LEFT

**DESIGN FIRM** CHARLES S. ANDERSON
  DESIGN COMPANY
**ART DIRECTOR** CHARLES S. ANDERSON
**DESIGNER** CHARLES S. ANDERSON/
  PAUL HOWALT
**COPY** LISA PEMRICK
**CLIENT/STORE** FRENCH PAPER CO.

**DESIGN FIRM** CHARLES S. ANDERSON
  DESIGN COMPANY
**ART DIRECTOR** CHARLES S. ANDERSON
**DESIGNER** CHARLES S. ANDERSON/
  DANIEL OLSAR
**ILLUSTRATOR/ARTIST** RANDALL DAHLL
**CLIENT/STORE** LEVI STRAUSS

**DESIGN FIRM** BONITA PIONEER
**ART DIRECTOR** JIM PARKER
**DESIGNER** JIM PARKER
**CLIENT/STORE** CELLULAR ONE

**DESIGN FIRM** CHARLES S. ANDERSON
  DESIGN COMPANY
**ART DIRECTOR** CHARLES S. ANDERSON
**DESIGNER** DANIEL OLSAR
**CLIENT/STORE** HOLLYWOOD PARAMOUNT
  PRODUCTS

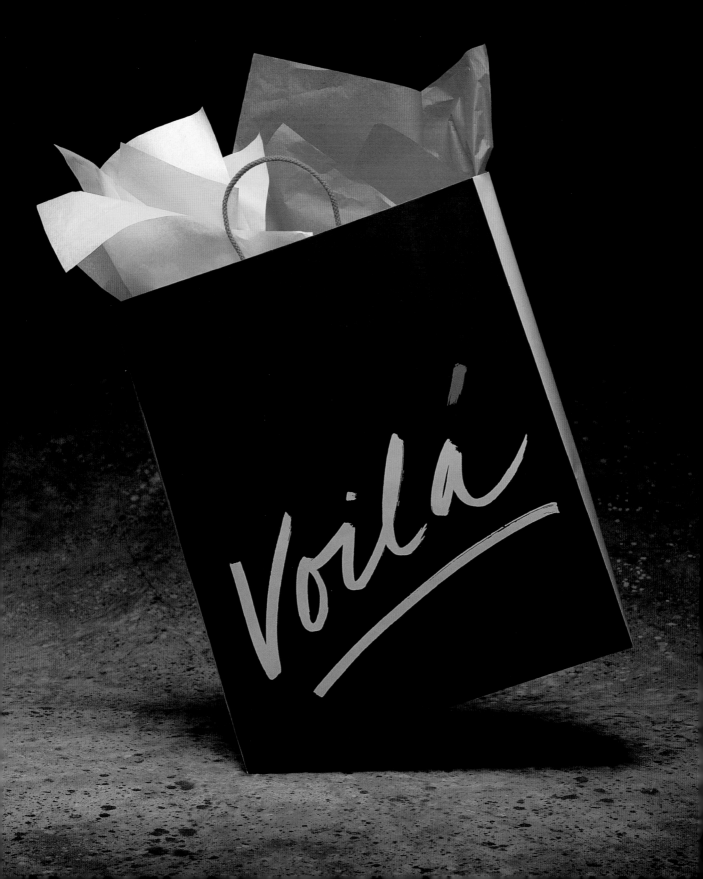

CHICAGO

CHICAGO DISTANCE

CLASSIC

ASSOCIATION

SUNDAY JULY 19, 1992

CHICAGO, ILLINOIS

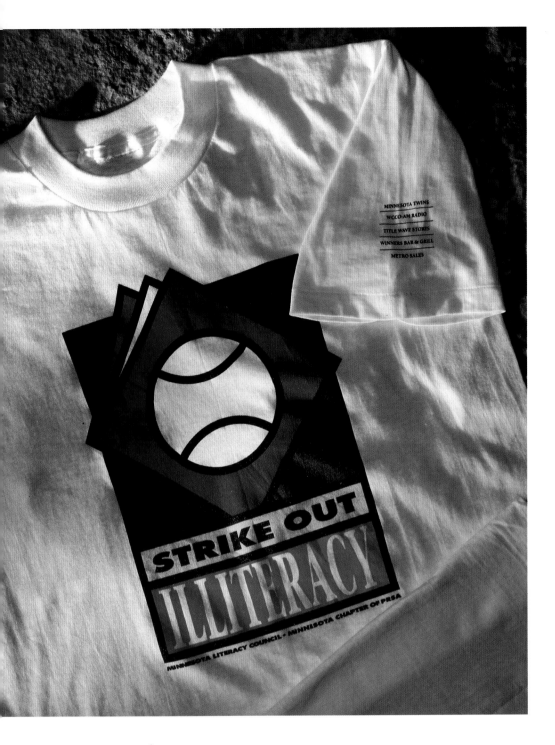

CLOCKWISE FROM LEFT

**Event** Promotional
**Design Firm** Segura Inc.
**Art Director** Carlos Segura
**Designer** Carlos Segura
**Illustrator** Mary Flock Lempa
**Client** The Chicago Lung Association
      Distance Classic

**Event** Promotion with Minnesota Twins
      "Strike out Illiteracy"
**Design Firm** Carmichael-Lynch
**Art Director** Peter Winecke
**Designer** Peter Winecke
**Illustrator** Peter Winecke
**Client** Minnesota Illiteracy Council

Logo designed on Mac.

**Event** Computer conference
**Design Firm** Sibley/Peteet Design
**Art Director** Tim Robbinson
**Designer** Tim Robbinson
**Illustrator** Tim Robbinson
**Client** Texas AIGA

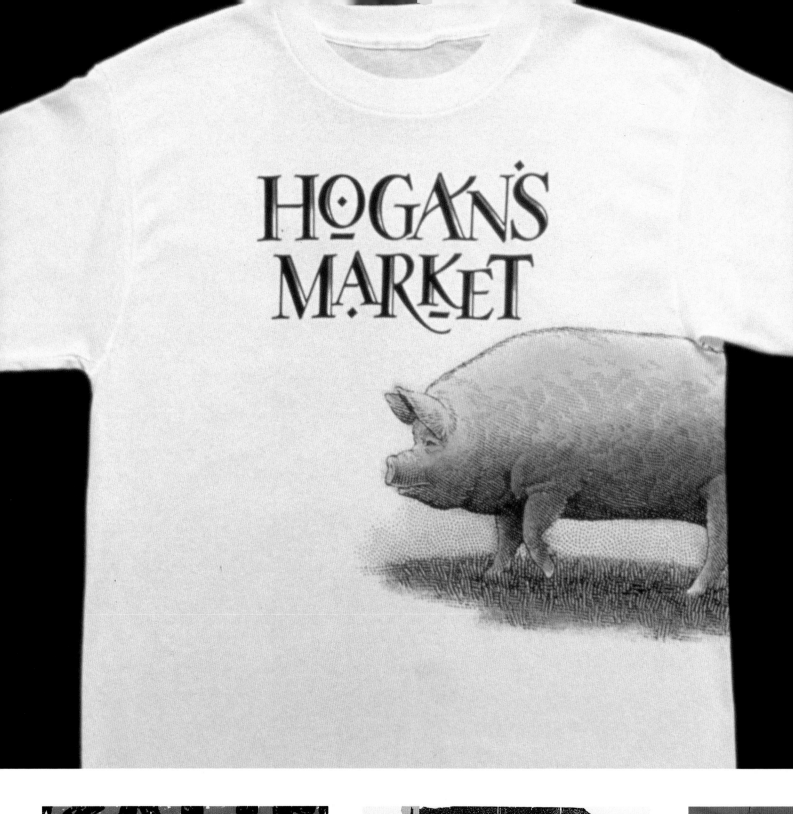

# HOGAN'S MARKET

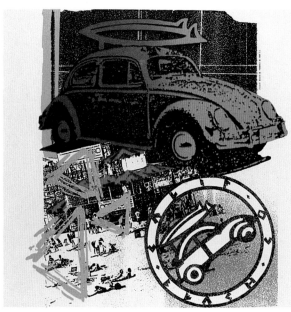

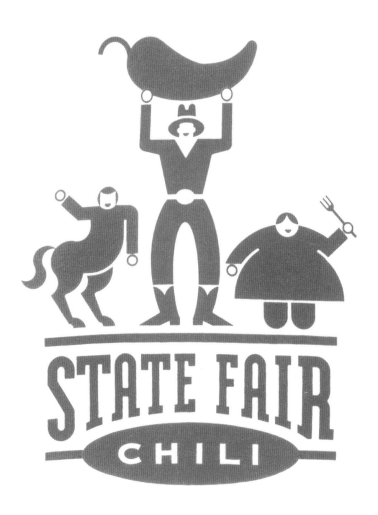

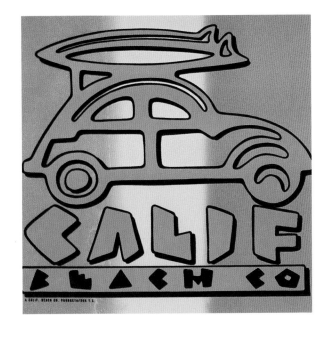

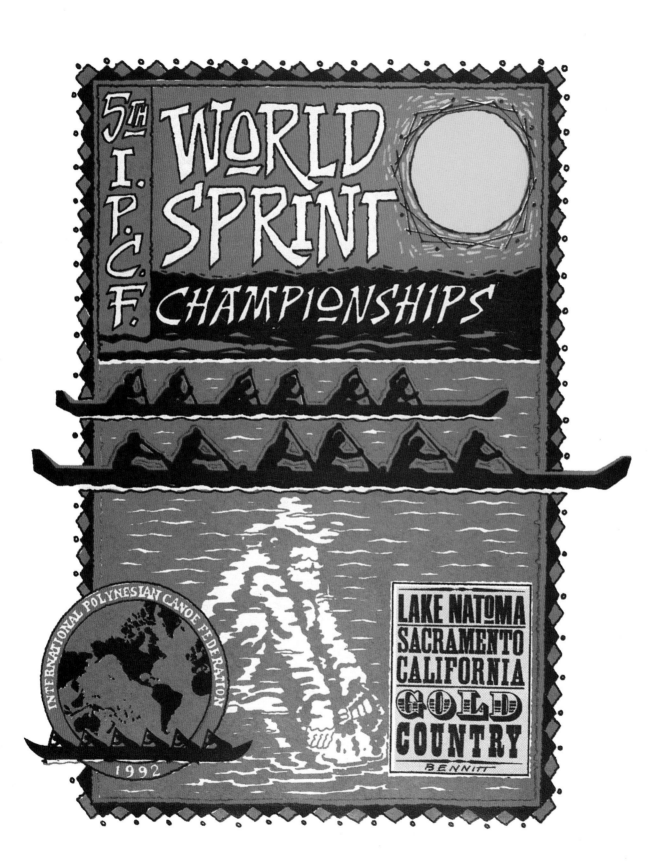

FROM TOP LEFT

**EVENT** RETAIL
**DESIGN FIRM** CREATIVE ARTS GROUP
**ART DIRECTOR** GAYLORD BENNITT
**DESIGNER** GAYLORD BENNITT
**ILLUSTRATOR** GAYLORD BENNITT
**CLIENT** INTERNATIONAL CANOE FEDERATION WORLD
CHAMPIONSHIPS

**EVENT** LOGO
**DESIGN FIRM** BRIGHT & ASSOCIATES
**ART DIRECTOR** KONRAD BRIGHT
**DESIGNER** KONRAD BRIGHT
**CLIENT** KETCHUM ADVERTISING

**EVENT** LOGO FOR COMPANY
**DESIGN FIRM** BRIGHT & ASSOCIATES
**ART DIRECTOR** KONRAD BRIGHT
**DESIGNER** KONRAD BRIGHT
**ILLUSTRATOR** KONRAD BRIGHT
**CLIENT** TERRANOVA CONSTRUCTION

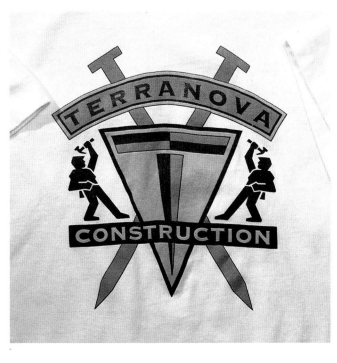

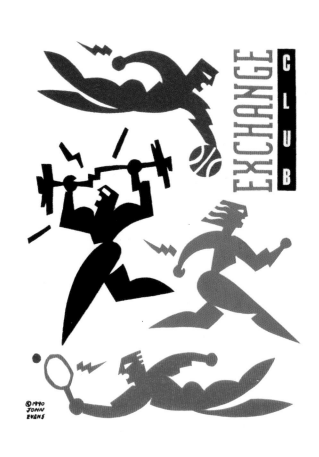

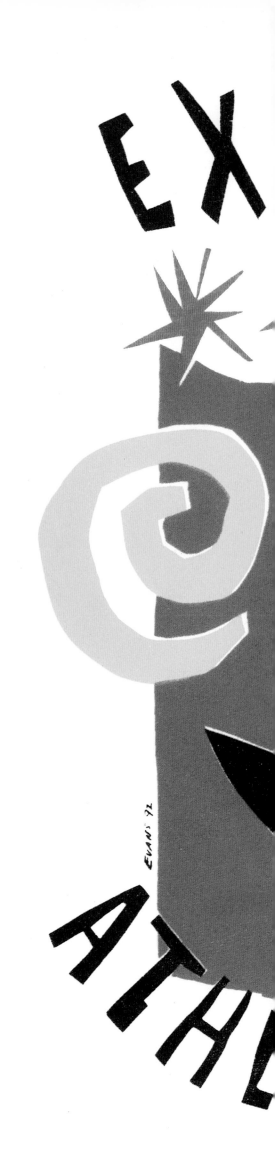

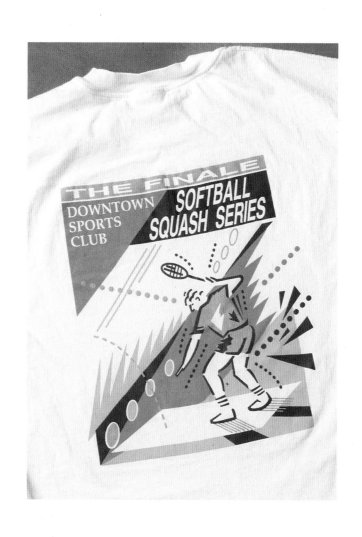

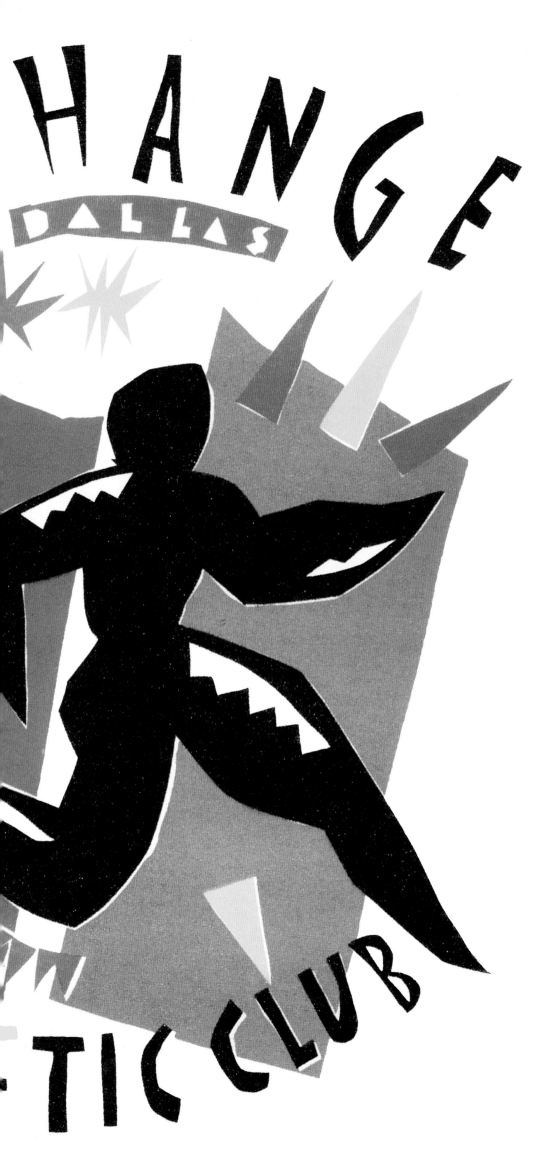

**EVENT** Retail
**DESIGN FIRM** John Evans Design
**ART DIRECTOR** John Evans
**DESIGNER** John Evans
**ILLUSTRATOR** John Evans
**CLIENT** Exchange Athletic Club

**EVENT** Squash Tournament Finals
**DESIGN FIRM** Jim Lange Design
**ART DIRECTOR** Jim Lange
**DESIGNER** Jim Lange
**ILLUSTRATOR** Jim Lange
**CLIENT** Downtown Sports Club

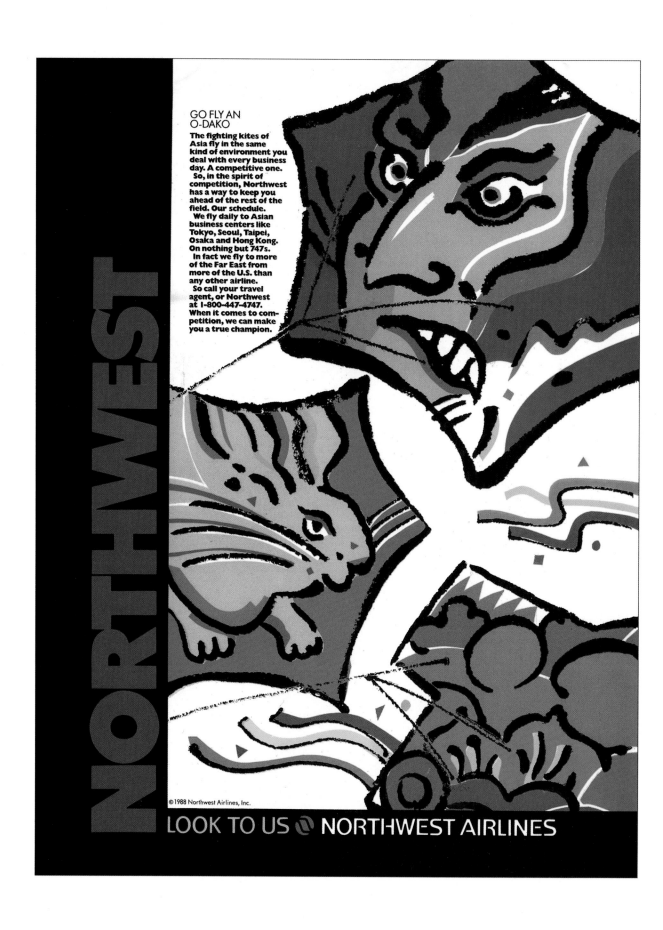

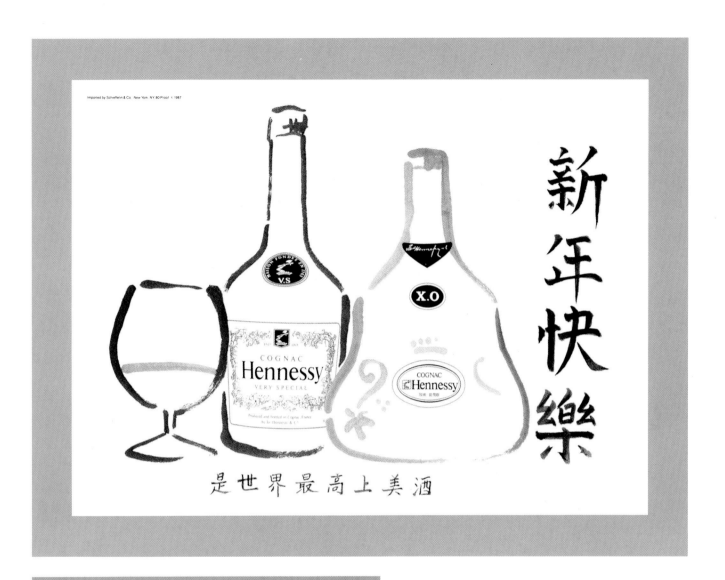

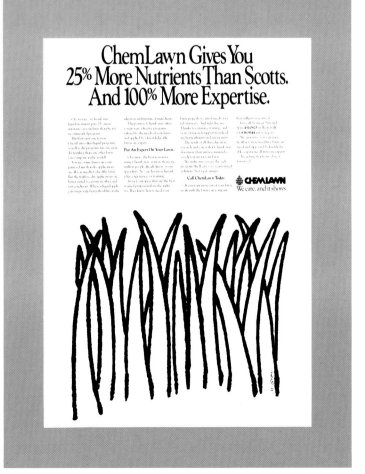

On this spread are examples of a simple illustrative brush style that presents a bold and direct image. **Mike Quon** depicts the fighting kites of Asia *(far left)* in bold, colorful strokes. This gives the effect of the Orient that is inherent in the message of the ad. On this page are two examples of his successful use of the brush in black and white. These ads, one for Hennessy *(top)* and one for ChemLawn *(bottom)*, have a subjective nature to them that is directly attributable to the freehand style used.

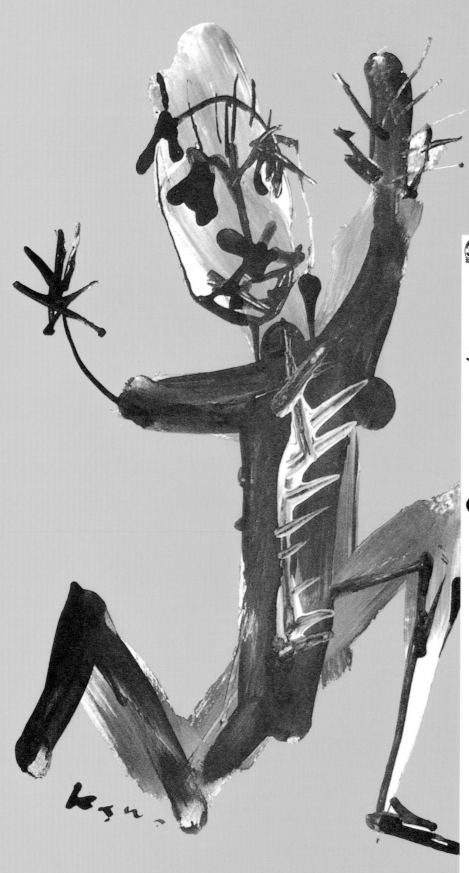

Once again, black and white newspaper advertising becomes the perfect spot for the freehand stroke. In these two ads designer Masakazu Fujii uses the childlike gesture sketches of **Hideyuki Kawarasaki** to express a playful attitude that works well with the simple directness of the typography.

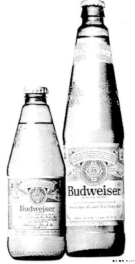

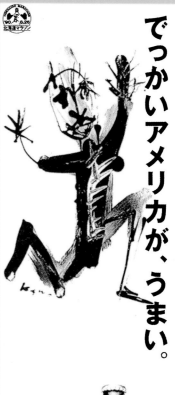

でっかいアメリカが、うまい。

BIG BUD
「ビッグバド」新発売

Budweiser    KING OF
NO.1         BEERS
アメリカンビール

希望小売価格　600mlビン　340円　355mlビン　240円　（消費税込み）

'90北海道マラソン 今年もサントリーが全面的に支援します

協賛　サントリー株式会社 北海道支社

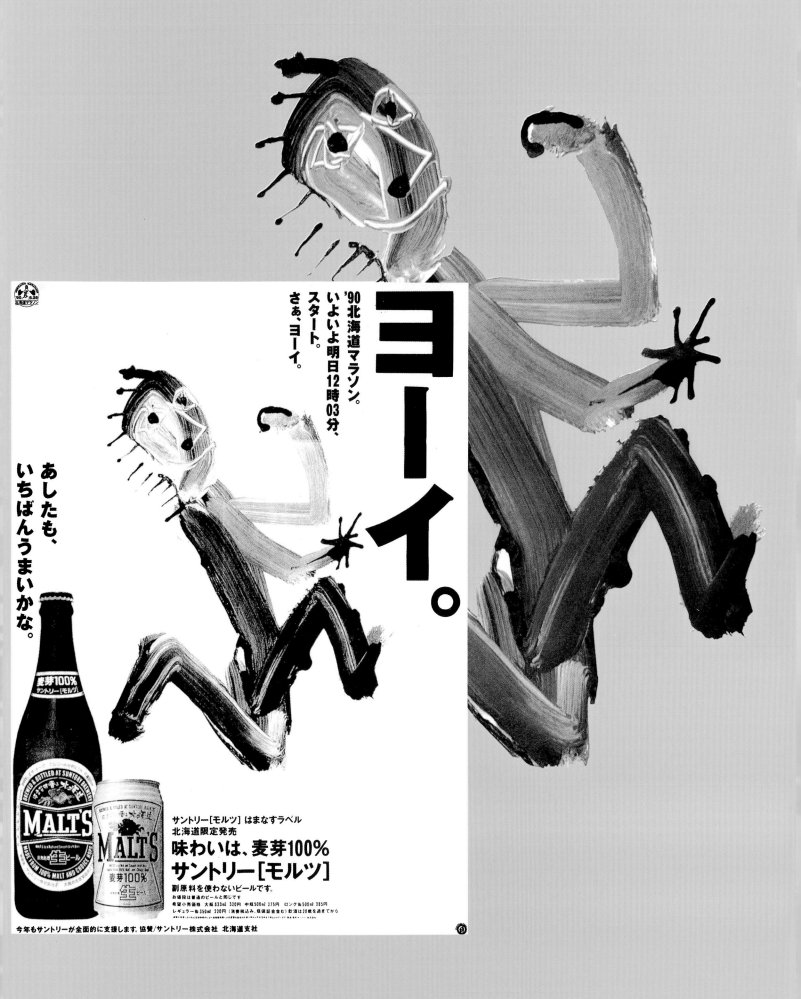

Make Your Mark
on Signature from Mead

**Georgia Deaver** produced the calligraphic art for this promotional piece for Mead Paper Co. Designed by the Van Dyke Company with photography by Terry Heffernan, this work reflects the name of the paper being promoted, Signature from Mead. Her art conveys the impression both subjectively and literally of a multi-purpose example of what can be achieved with the human hand.

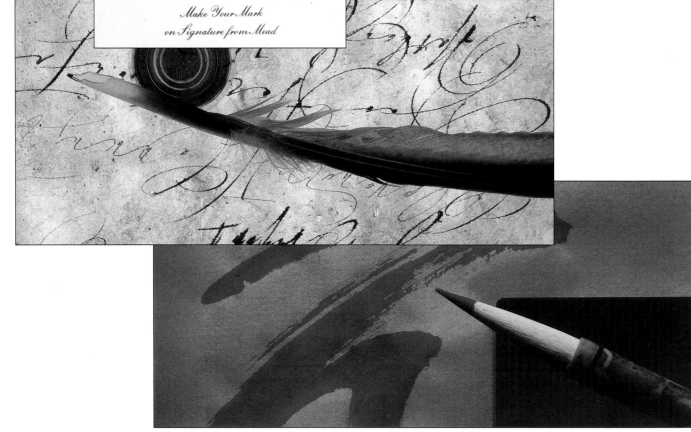

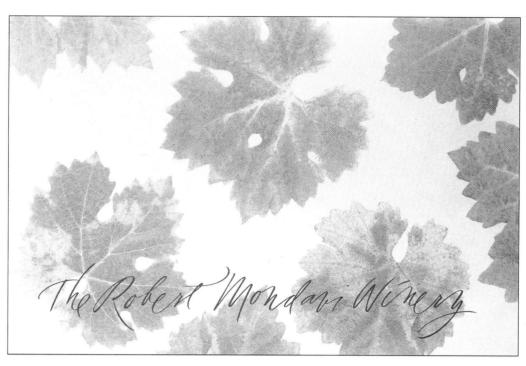

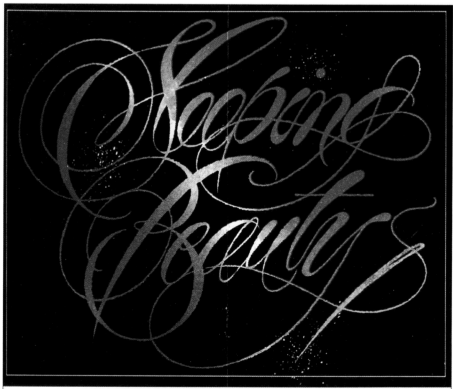

Georgia contributed her talent to this literature piece *(top)* designed by Pate International for the Robert Mondavi Winery. The delicate lettering sits well within this subtle design. *Below*, in contrast, this bold announcement for the San Francisco Ballet brings to the dance program excitement and magic.

**Sleeping Beauty**
*Tomasson (Petipa)/*
*Tchaikovsky/ Worsaae*

*New Full Length Production*

*World Premiere*

*J*oin us this season as we add a sparkling new production of *Sleeping Beauty.* In celebration of the ballet's 100th anniversary, Helgi Tomasson and designer Jens-Jacob Worsaae, whose *Swan Lake* won critical acclaim, have once again joined forces to create a stunning new ballet which is sure to seize your imagination and capture your heart.

*Sleeping Beauty* represents the grandest achievement of classical ballet and offers thrilling bravura performances. From the romance of Princess Aurora and Prince Florimund's Pas de Deux to a colorful array of fairy tale characters, you won't want to miss this joyous experience of dance, music, and theatre. A delight for the whole family to cherish for all time.
*Included on all 8 and 5 performance series, or order your individual tickets now!*

**Sleeping Beauty**
**1990 Performance Dates**

March

| Sun | Mon | Tues | Wed | Thur | Fri | Sat |
|-----|-----|------|-----|------|-----|-----|
|     |     | **13** 8pm | **14** 8pm | **15** 8pm | **16** 8pm |     |
|     |     |      |     |      |     | **24** 2pm 8pm |
| **25** 2pm 7pm |     |      |     |      |     |     |

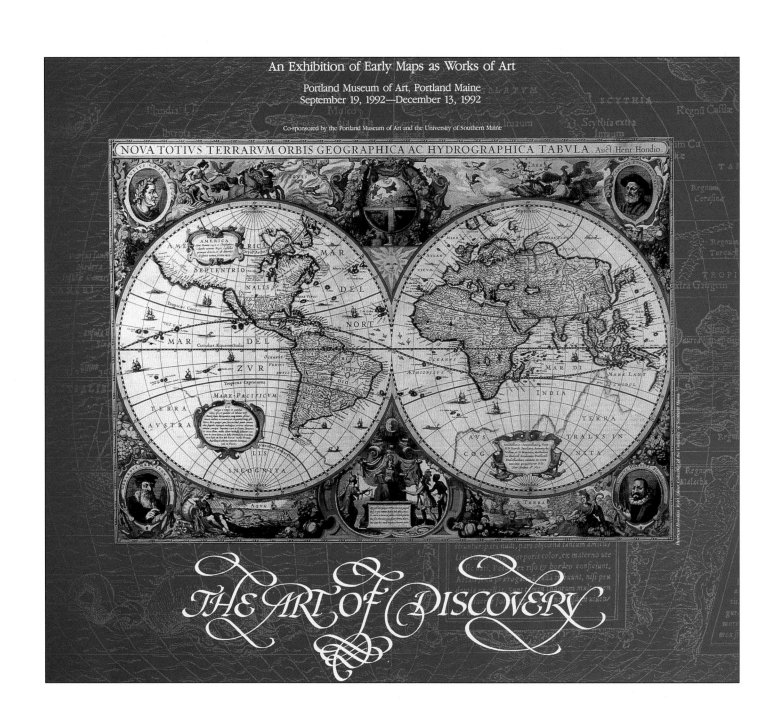

An Exhibition of Early Maps as Works of Art

Portland Museum of Art, Portland Maine
September 19, 1992—December 13, 1992

Co-sponsored by the Portland Museum of Art and the University of Southern Maine

**DESIGNER** CAMILLE BUSH
**ART** MAP FROM THE OSHER COLLECTION OF USM BY HENRICHS HONDINS
**CLIENT** THE UNIVERSITY OF SOUTHERN MAINE

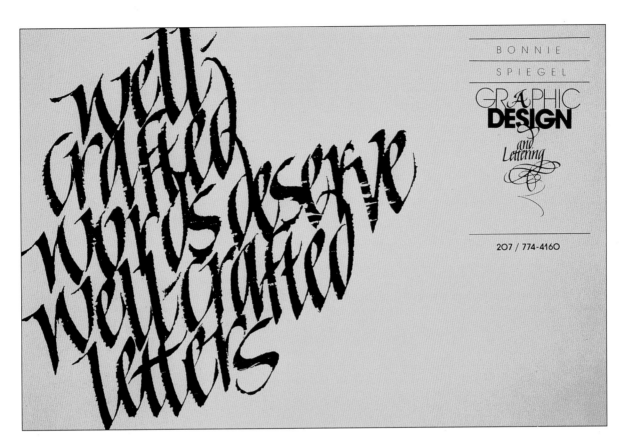

**Designer/Calligrapher** Bonnie Spiegel
**Client** Self-promotion

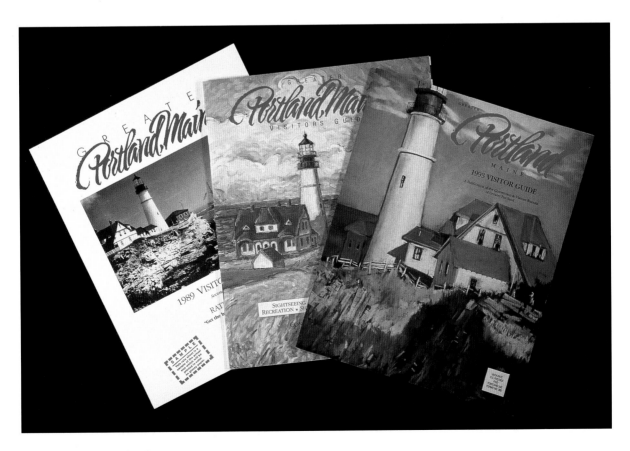

**Illustrators** Stephen Burr, Gary Symington
**Client** Portland Chamber of Commerce Convention and Visitor's
Bureau Barbara Whitten, Coordinator

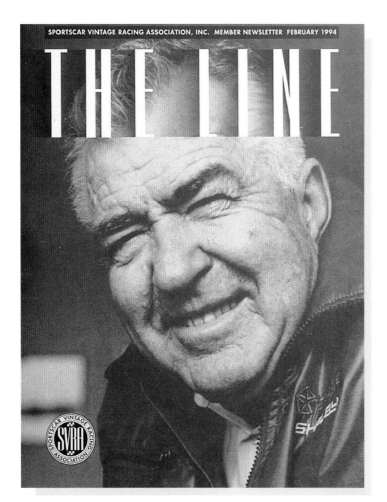

# THE LINE

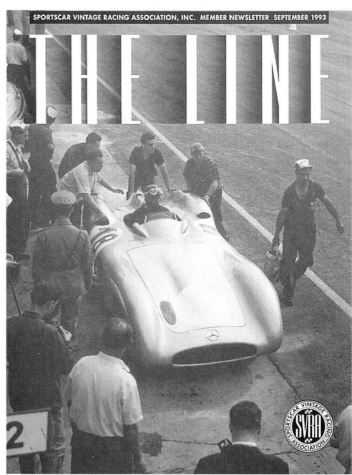

# THE LINE

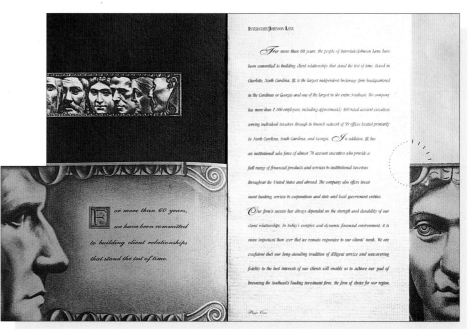

FROM TOP

**DESIGN FIRM** MULLER + COMPANY
**ART DIRECTOR** JOHN MULLER
**DESIGNER** JOHN MULLER
**PHOTOGRAPHER** JESSE ALEXANDER
**CLIENT** SPORTSCAR VINTAGE RACING
ASSOCIATION

The biggest challenge was getting the various elements in the different pages and sections to register. This was done by careful planning on the part of the designer, the illustrator, and the printer.

**DESIGN FIRM** MERVIL PAYLOR DESIGN
**ART DIRECTOR** MERVIL M. PAYLOR
**DESIGNER** MERVIL M. PAYLOR
**ILLUSTRATOR** DAVID WILGUS
**COPYWRITER** DEBORA ARNOLD
**CLIENT** INTERSTATE JOHNSON LANE

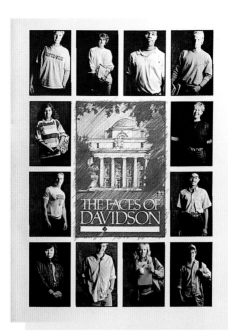

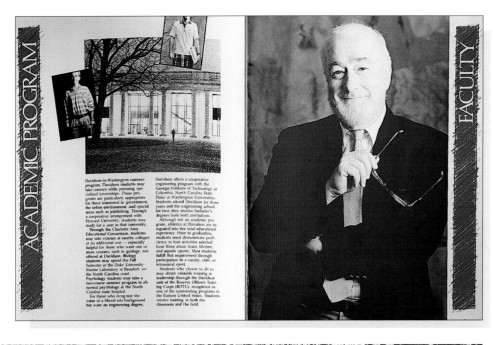

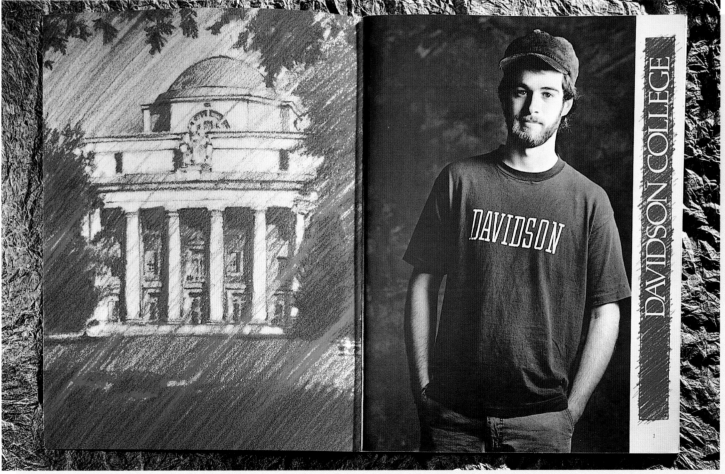

The portrait photography began as a personal
project for the photographer, a Davidson alumni.
He later allowed the college to use the photos
for recruiting materials.

**DESIGN FIRM** MERVIL PAYLOR DESIGN
**ART DIRECTOR** MERVIL M. PAYLOR
**DESIGNER** MERVIL M. PAYLOR
**ILLUSTRATOR** GARY PALMER
**PHOTOGRAPHER** RON CHAPPLE
**COPYWRITER** SHERYL AIKMAN
**CLIENT** DAVIDSON COLLEGE

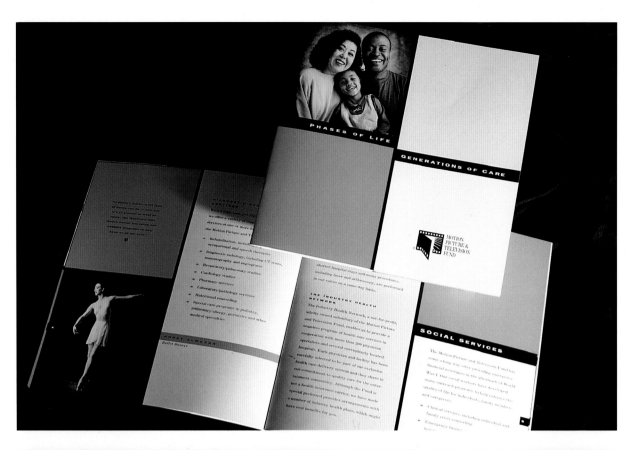

FROM TOP

**DESIGN FIRM** VRONTIKIS DESIGN OFFICE
**ART DIRECTOR** PETRULA VRONTIKIS
**DESIGNER** PETRULA VRONTIKIS
**PHOTOGRAPHER** JEFF SEDLIK
**COPYWRITER** LOUELLA BENSON
**CLIENT** MOTION PICTURE & TELEVISION FUND

**DESIGN FIRM** VRONTIKIS DESIGN OFFICE
**ART DIRECTOR** PETRULA VRONTIKIS
**DESIGNER** KIM SAGE
**PHOTOGRAPHER** JEFF SEDLIK
**CLIENT** MOTION PICTURE & TELEVISION FUND

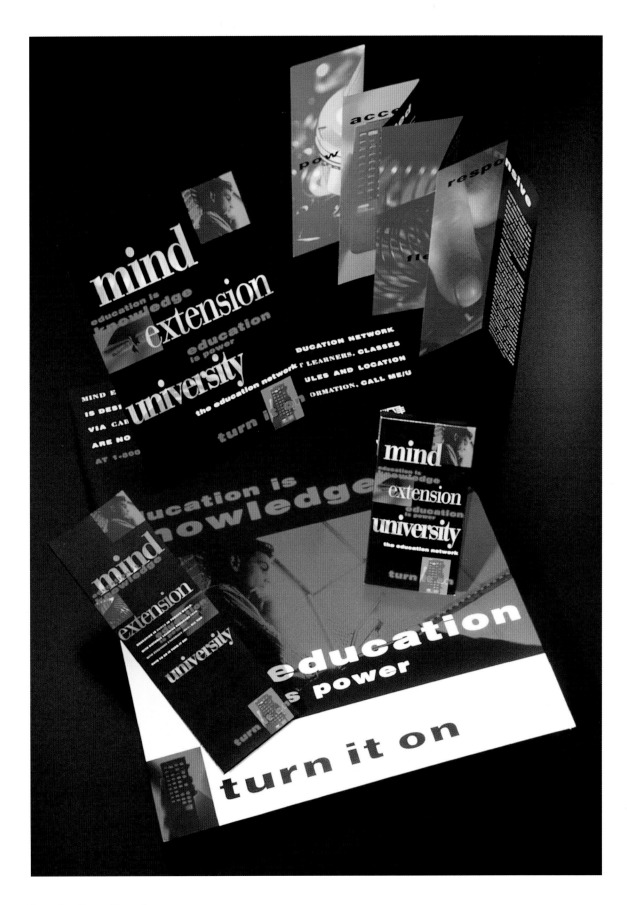

**Design Firm** Vaughn Wedeen Creative
**Art Director** Steve Wedeen
**Designer** Steve Wedeen
**Photographer** Michael Barley/Stock Photography
**Copywriter** Steve Wedeen/Nathan James
**Computer Manipulation/Production** Chip Wyly
**Client** Mind Extension University

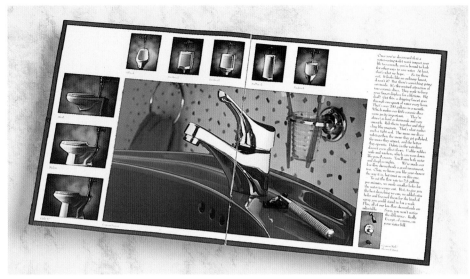

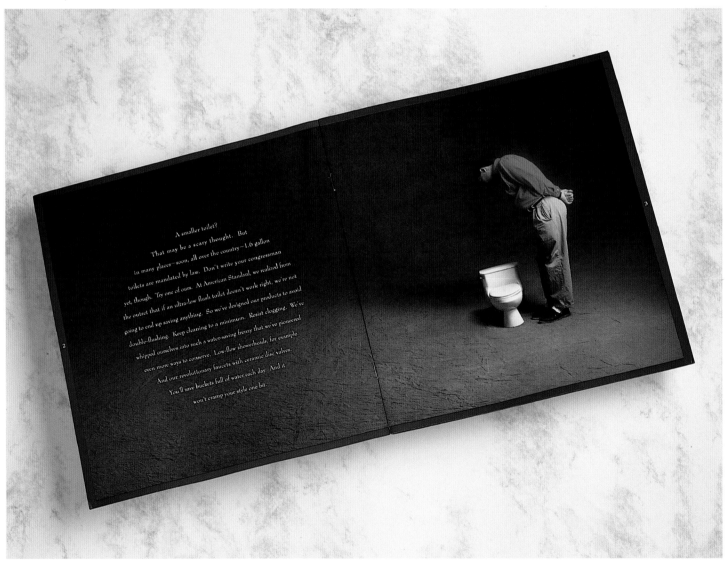

**DESIGN FIRM** CARMICHAEL LYNCH
**ART DIRECTOR** PETER WINECKE
**DESIGNER** PETER WINECKE
**PHOTOGRAPHER** LARS HANSON
**COPYWRITER** JOHN NEUMANN
**CLIENT** AMERICAN STANDARD

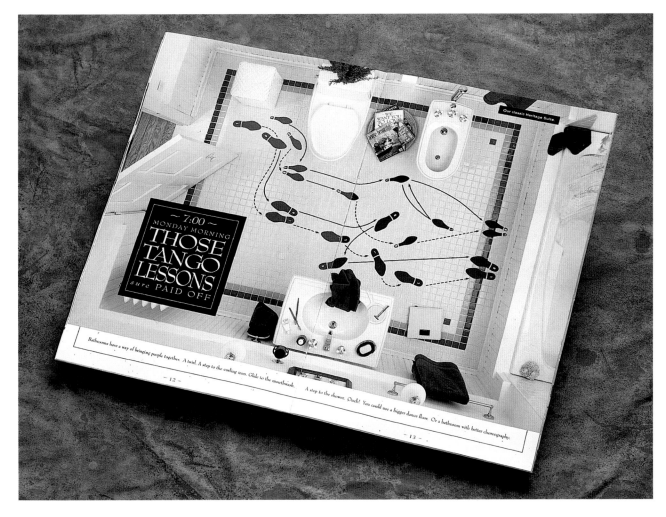

**DESIGN FIRM** CARMICHAEL LYNCH
**ART DIRECTOR** PETER WINECKE
**DESIGNER** PETER WINECKE
**PHOTOGRAPHER** LARS HANSON/STEVE MCHUGH
**COPYWRITER** JOHN NEUMANN
**CLIENT** AMERICAN STANDARD

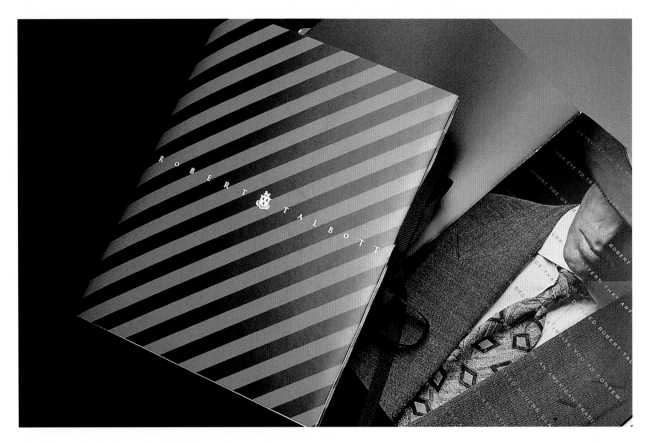

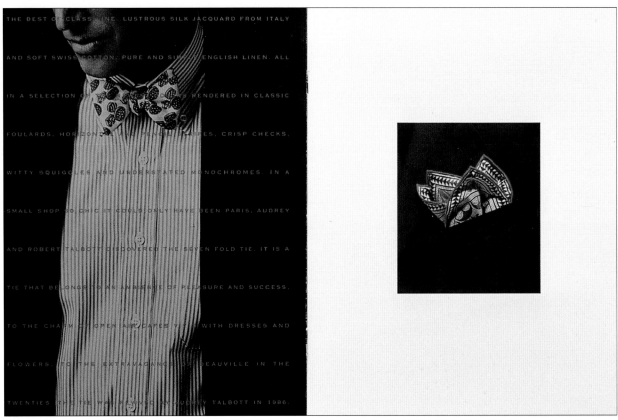

**DESIGN FIRM** VANDERBYL DESIGN
**ART DIRECTOR** MICHAEL VANDERBYL
**DESIGNER** MICHAEL VANDERBYL
**PHOTOGRAPHER** DAVID PETERSON
**COPYWRITER** PENNY BENDA
**CLIENT** ROBERT TALBOTT, INC.

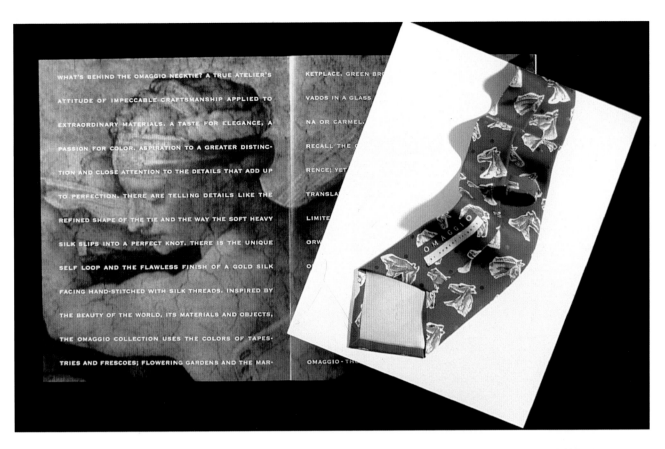

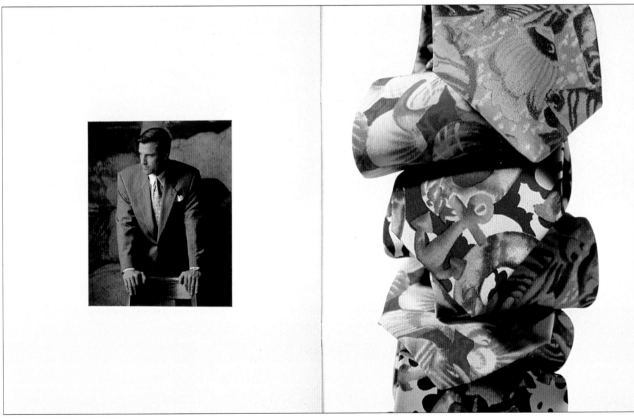

**Design Firm** Vanderbyl Design
**Art Director** Michael Vanderbyl
**Designer** Michael Vanderbyl
**Photographer** David Peterson
**Copywriter** Penny Benda
**Client** Robert Talbott, Inc.

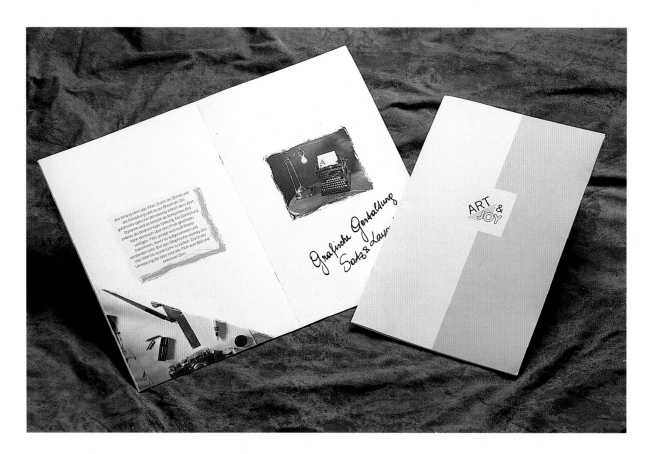

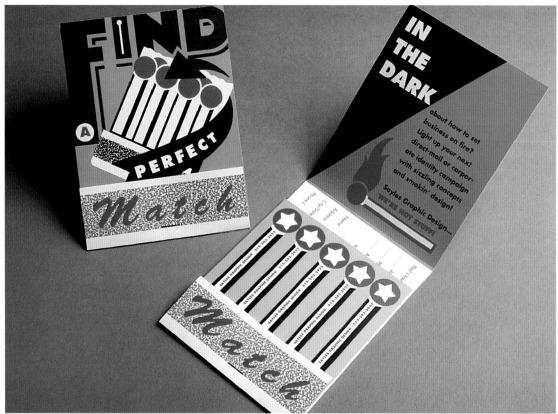

FROM TOP

**DESIGN FIRM** ART & JOY
**ART DIRECTOR** CHRISTIAN HOFBAUER
**PHOTOGRAPHER** ROBERT MÜLLER
**COPYWRITER** ART & JOY
**CLIENT** ART & JOY

**DESIGN FIRM** SAYLES GRAPHIC DESIGN
**ART DIRECTOR** JOHN SAYLES
**DESIGNER** JOHN SAYLES
**ILLUSTRATOR** JOHN SAYLES
**COPYWRITER** WENDY LYONS
**CLIENT** SAYLES GRAPHIC DESIGN

Art Direction, Graphic Design
and Creative Concepts to Improve
Both Your Image and Your
Bottom Line

**THE BEST WEAPON IN A TOUGH MARKET PLACE IS A GOOD IDEA**

# Rickabaugh Graphics

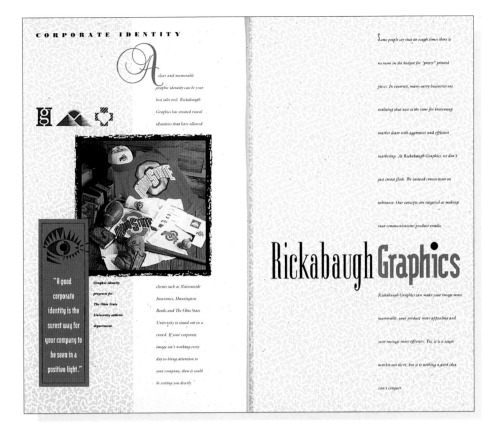

## CORPORATE IDENTITY

A clear and memorable graphic identity can be your best sales tool. Rickabaugh Graphics has created visual identities that have allowed

"A good corporate identity is the surest way for your company to be seen in a positive light."

Graphic identity program for The Ohio State University athletic department.

clients such as Nationwide Insurance, Huntington Banks and The Ohio State University to stand out in a crowd. If your corporate image isn't working every day to bring attention to your company, then it could be costing you dearly.

Some people say that in tough times there is no room in the budget for "pretty" printed pieces. In contrast, many savvy businesses are realizing that now is the time for increasing market share with aggressive and efficient marketing. At Rickabaugh Graphics, we don't just create flash. We instead concentrate on substance. Our concepts are targeted at making your communications produce results.

## Rickabaugh Graphics

Rickabaugh Graphics can make your image more memorable, your product more appealing and your message more effective. Yes, it is a tough market out there, but it is nothing a good idea can't conquer.

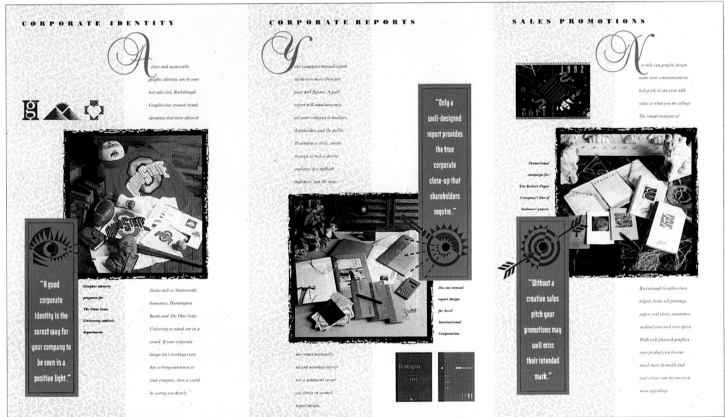

## CORPORATE IDENTITY

A clear and memorable graphic identity can be your best sales tool. Rickabaugh Graphics has created visual identities that have allowed

"A good corporate identity is the surest way for your company to be seen in a positive light."

Graphic identity program for The Ohio State University athletic department.

clients such as Nationwide Insurance, Huntington Banks and The Ohio State University to stand out in a crowd. If your corporate image isn't working every day to bring attention to your company, then it could be costing you dearly.

## CORPORATE REPORTS

Your company's annual report needs to be more than just facts and figures. A good report will simultaneously sell your company to analysts, shareholders and the public. Presenting a clear, concise message to such a diverse audience is truly a difficult endeavor. Just the same.

"Only a well-designed report provides the true corporate close-up that shareholders require."

Die-cut annual report design for Accel International Corporation.

our many nationally awarded winning reports are a testament to our excellence in annual report design.

## SALES PROMOTIONS

Not only can graphic design make your communications look good, it can even add value to what you are selling. The visual creations of

Promotional campaign for The Beckett Paper Company's line of Embassy papers.

"Without a creative sales pitch your promotions may well miss their intended mark."

Rickabaugh Graphics have helped clients sell printing, paper, real estate, insurance, medical care and even opera. With well-planned graphics your product can become much more desirable and your service can become even more appealing.

Brochures were drilled so that drill hole functions as pupil of eye, magnifying glass "hot spot," bullseye, and dot of "i" simultaneously.

**DESIGN FIRM** RICKABAUGH GRAPHICS
**ART DIRECTOR** ERIC RICKABAUGH
**DESIGNER** ERIC RICKABAUGH
**ILLUSTRATOR** ERIC RICKABAUGH
**PHOTOGRAPHER** PAUL POPLIS
**COPYWRITER** ERIC RICKABAUGH
**CLIENT** RICKABAUGH GRAPHICS

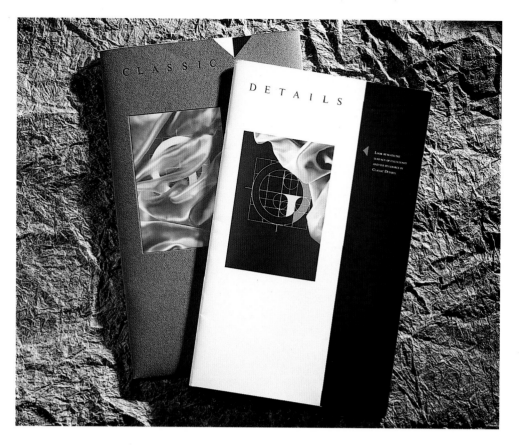

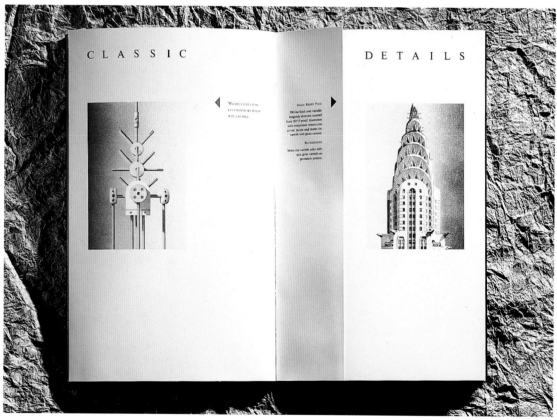

**Design Firm** Mervil Paylor Design
**Art Director** Mervil M. Paylor
**Designer** Mervil M. Paylor
**Illustrator** David Wilgus/Gary Palmer
**Photographer** Gerin Choiniere
**Copywriter** Melissa Stone
**Client** Classic Graphics

'Would you help me to become a Guide Dog?'

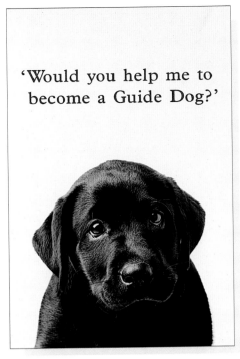

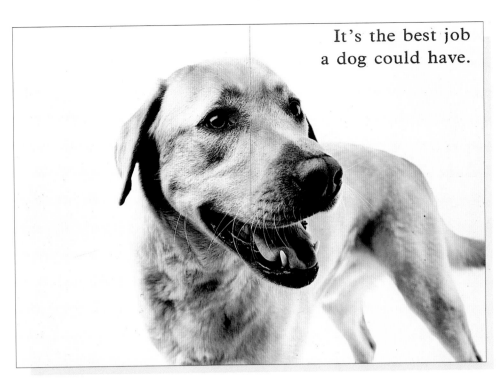

It's the best job a dog could have.

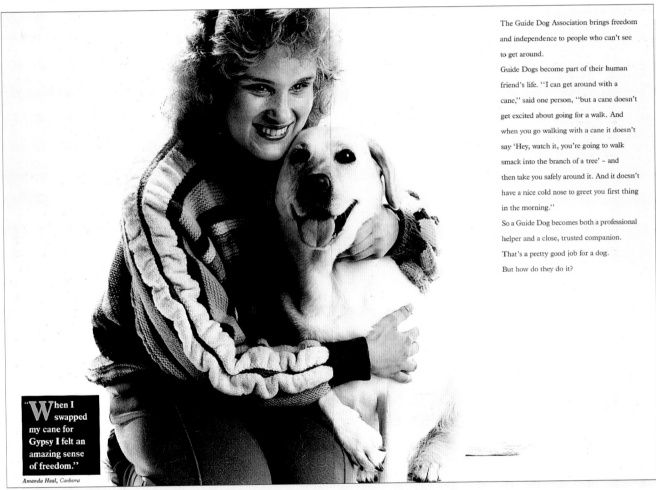

"When I swapped my cane for Gypsy I felt an amazing sense of freedom."

*Amanda Heal, Canberra*

The Guide Dog Association brings freedom and independence to people who can't see to get around.

Guide Dogs become part of their human friend's life. "I can get around with a cane," said one person, "but a cane doesn't get excited about going for a walk. And when you go walking with a cane it doesn't say 'Hey, watch it, you're going to walk smack into the branch of a tree' – and then take you safely around it. And it doesn't have a nice cold nose to greet you first thing in the morning."

So a Guide Dog becomes both a professional helper and a close, trusted companion. That's a pretty good job for a dog.

But how do they do it?

**DESIGN FIRM** RAYMOND BENNETT DESIGN PTY. LTD.
**ART DIRECTOR** RAYMOND BENNETT
**DESIGNER** RAYMOND BENNETT/GINA BATSAKIS
**PHOTGRAPHER** MARK LLEWELLYNN
**COPYWRITER** PETER FERGUSON
**CLIENT** GLEN BUTTERWORTH/GUIDE DOG ASSOCIATION

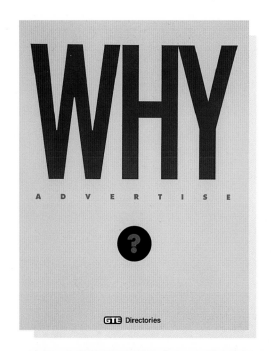

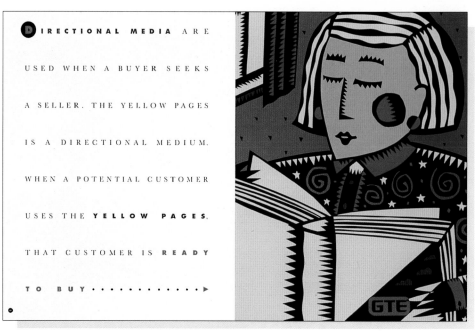

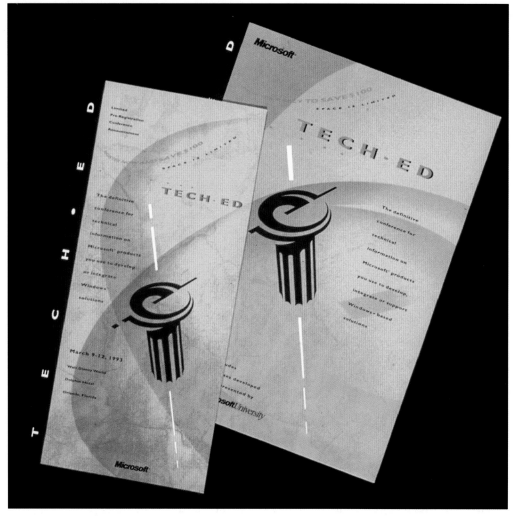

**DESIGN FIRM** SULLIVANPERKINS
**ART DIRECTOR** RON SULLIVAN
**DESIGNER** JON FLAMMING
**ILLUSTRATOR** JON FLAMMING
**COPYWRITER** MARK PERKINS/HILARY KENNARD
**CLIENT** GTE DIRECTORIES CORPORATION

**DESIGN FIRM** HORNALL ANDERSON DESIGN WORKS
**ART DIRECTOR** JACK ANDERSON
**DESIGNER** JACK ANDERSON/CLIFF CHUNG/DAVID BATES
**ILLUSTRATOR** SCOTT MCDOUGALL
**COPYWRITER** MICROSOFT CORPORATION
**CLIENT** MICROSOFT CORPORATION

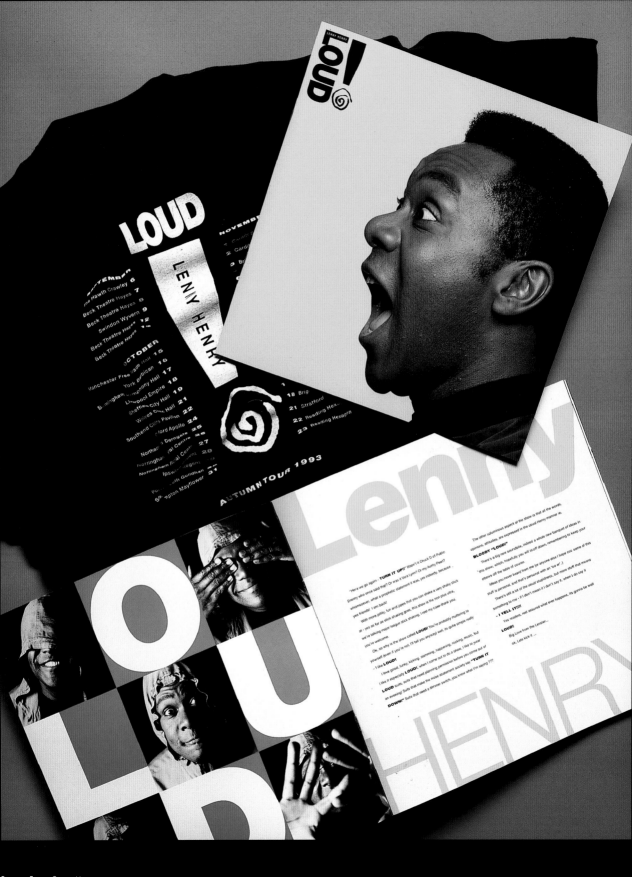

**DESIGN FIRM** GREEN HOUSE
**ART DIRECTOR** JUDI GREEN
**DESIGNER** JUDI GREEN/JAMES BELL
**PHOTOGRAPHER** TREVOR LEIGHTON
**CLIENT** LENNY HENRY

31014          $14.99

ISBN 1-56496-157-5

90000

9 781564 961570